Life

2 5 APR 2017

1 8 OCT 2019

Ton

Books should be returned or renewed by the last date above. Renew by phone **08458 247 200** or online *www.kent.gov.uk/libs*

743·4

Libraries & Archives

Dedication

To my parents, Grace and Fred Armer, and
to Alan Swapp, an inspirational art teacher,
who persuaded them to allow me to go to art
school way back in 1971.

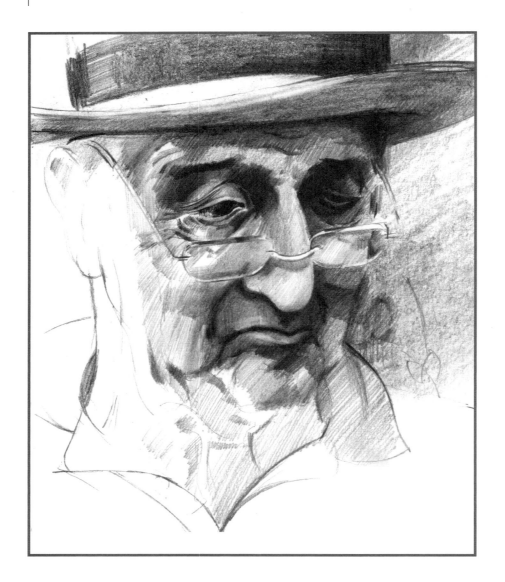

Life Drawing

Eddie Armer

SEARCH PRESS

First published in Great Britain 2013

Search Press Limited
Wellwood, North Farm Road,
Tunbridge Wells, Kent TN2 3DR

ISBN: 978-1-84448-818-6

The Publishers and author can accept
no responsibility for any consequences
arising from the information, advice or
instructions given in this publication.

Suppliers
If you have difficulty in obtaining
any of the materials and equipment
mentioned in this book, then please
visit the Search Press website for
details of suppliers:
www.searchpress.com

Printed in Malaysia

Acknowledgements

Thanks to Clelia Rinaldi, Bernie Grandison,
Andrea Jameson and Martin Lubikowski for their
support. Also to the workshops I have been able to
run over the years unhindered, including La Capella
(Glenda Richardson, Pierra and Lorenzo Barberi), the
Topolski Century (Anna Blaisik), the Courtauld Institute
Students' Union (Daisy Jones), the Goldsmid Hall and
Search Press. Also to the many excellent models I have
worked with over the years including those featured in
this book: Anne, Dee, Eve, Jane, Joanna, Kimberley,
Leticia, Lydia, Moss, Nelly, Sharon, Tom and Quilici.

Front cover
Leticia
*HB graphite pencil on cartridge paper.
One hour study.*

Page 1
Male Torso
*Wax crayon on newsprint.
Ten minute pose.*

Page 3
Foreshortened Torso
*Wax crayon on cartridge
paper. One hour study.*

Opposite
Female Figure
A two minute gesture drawing in charcoal.

Contents

Introduction

A scribble drawing in ballpoint pen on cartridge paper. A thirty-minute pose.

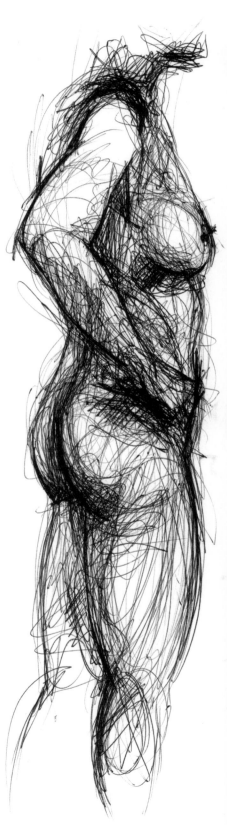

Why is life drawing so important to the visual artist? To be able to draw accurately that which is in front of you, be it a tree, a vase or a human figure, is a fundamental part of being an artist, and the human form is the most challenging of all subjects to study. There is no better way to train your hand, eye and brain coordination and develop your powers of observation than to attend a life drawing workshop. Life drawing is not only about learning to draw the body accurately; it also teaches you to translate our complex three-dimensional world and to represent it two-dimensionally within the confines of a sheet of paper.

In this book I demonstrate a few of the drawing techniques and disciplines that I employ when working from life. The results may be loose and spontaneous, tight and considered or maybe abstracted, depending on the day, my mood and the model!

Models are obviously an integral part of the drawing process, so always work with experienced sitters. Inexperienced models may be able to hold a pose, but might not be aware of how to use their bodies in a way to challenge the artist, for example by showing the body under tension, relaxed, in movement or making a gesture. Good professional models can also project something of their personalities, enabling collaboration with the artist. For this reason, I often use dancers, actors or performers of some kind for my workshops.

Working from photographs certainly has its place in art, and by copying an image, you will hone your pencil skills, but this is no substitute for drawing from life. In a photograph, the camera has done the work for you by capturing an image and reproducing it as a flat two-dimensional photograph. As an artist, you have to take the place of the camera and work out how to represent tone, line, proportions, space and visual distortion through foreshortening and perspective in your drawing.

Through the practice of life drawing I have learnt not only to look, but to see. Learning to understand how the mind functions in different ways has helped free up my approach to drawing. For example, learning to dwell in the right-hand side of the brain, where you can work fast and intuitively, creates spontaneity, as opposed to using the left-hand side of the brain, where order and careful consideration will dominate your work. Musicians, when improvising, do not think of what they are about to play, but create music sponaneously. This demonstrates mainly right-brain activity. In contrast, a classical musician produces music by reading and interpreting a musical score in a controlled manner – demonstrating mainly left-brain activity. This same analogy can be applied to drawing. Auguste Rodin (1840–1917) was able to work in contrasting ways. His sculptural masterpiece 'The Kiss'

could only have been produced through consideration, contemplation and calculation, but Rodin was also an advocate of spontaneous drawing. Without looking at the paper, Rodin would produce a stream of free-flowing, often erotic sketches, capturing a model's gesture and littering the floor as he moved quickly from one drawing to the next.

The aim of this book is to encourage you to draw the human form in different ways. Life drawing is about learning to interpret the world visually through careful observation and freeing up the mind. I will demonstrate various approaches to drawing from life and a range of techniques and disciplines, to help give strength and variety to your work.

Finally, it is important to remember that life drawing is not a process designed to produce wonderful pieces of art. The intrinsic value of a life drawing lies in the doing and a 'good' drawing is only a by-product. The jazz trumpeter Miles Davis believed that, 'There are no mistakes in art' and I agree. As long as you remain focused when drawing, you will gain knowledge and understanding of the visual world – and maybe produce a good drawing or two.

I would also like to add a comment about developing a personal style. To merely copy from life is not enough, neither does it produce an interesting or individual work. Try to express yourself through an emotional response to the subject. I rarely decide before commencing a life drawing my choice of medium, the size or stylistic approach to the drawing. Various choices are made for me by my mood on the day, the model, the lighting and the pose. My frame of mind will dictate whether I work fast and intuitively, or in a slow and considered way. Draw what you feel and not just what you see. Gradually a personal style will emerge; do not try to cultivate one.

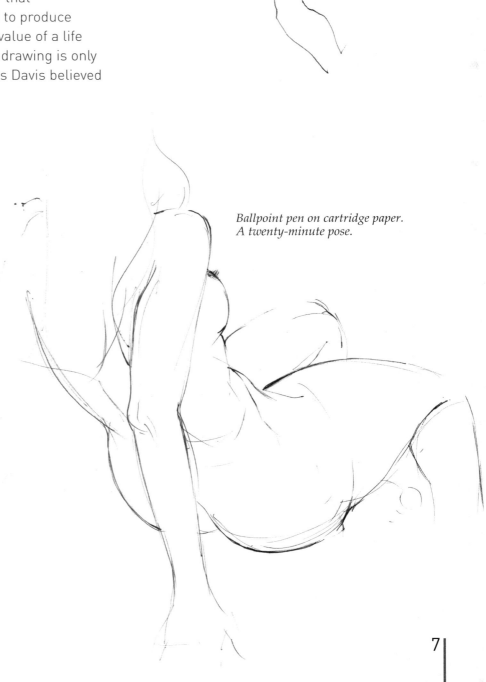

A figure executed in the style of a Rodin spontaneous life drawing.

Ballpoint pen on cartridge paper. A twenty-minute pose.

The history of life drawing

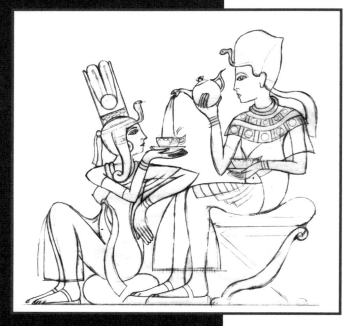

The human race has been drawing the human form since the first stick men appeared scrawled on cave walls by prehistoric man. In ancient times, the Egyptians, who had no concept of foreshortening, would draw a combination of front and side views within one figure. The shoulders appeared face on, as did the eyes, but head, legs and feet were viewed from the side (see my Egyptian style drawing, left).

The same concept is found in early Greek images which, although more developed, were still very stylised and flat. By the time of the Romans, foreshortening begins to appear in paintings, helping to create depth and realism.

There is written evidence that sketching from life was an established practice by the 13th century, but it is not until the time of the Italian Renaissance that we have records of scientific and artists' analysis of human anatomy.

Leonardo da Vinci (1452–1519) produced many studies and theories as to how the body functioned, as well as mathematical calculations demonstrating how body proportions worked in relationship to one another. Albrecht Durer (1471–1528) covered the same subject in his *Four Books on Human Proportion*, which were published shortly after his death.

Around 1585 the Italian painter Lodovico Carracci (1555–1619) founded the *Accademia degli Incamminati* in Bologna, placing life drawing as a central discipline and setting the template for all subsequent art academies.

There has always been a misunderstanding between sexuality and artistic expression from the unenlightened, confusing voyeurism with artistic challenge. Thank goodness that in these enlightened times we are able to draw female models for real, and do not have to resort to young boys wearing false breasts, as was common practice during the Renaissance. It is unlikely that Michelangelo ever drew an actual female nude. Towards the end of the 19th century in European

A study of a head in profile in the style of Leonardo da Vinci.

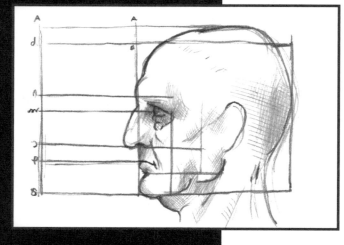

art schools, women artists were finally allowed to attend life drawing classes. Also, nude life models having to wear a face covering had become a thing of the past, but some modern-day institutions still insist on male models covering their genitals as a matter of propriety.

Life drawing has become popular again in recent years, with artists placing value on the practice of drawing the human form. I hope that this book helps to stimulate your creativity and hone your drawing skills. Creativity is about making mistakes and art is about knowing which ones to keep!

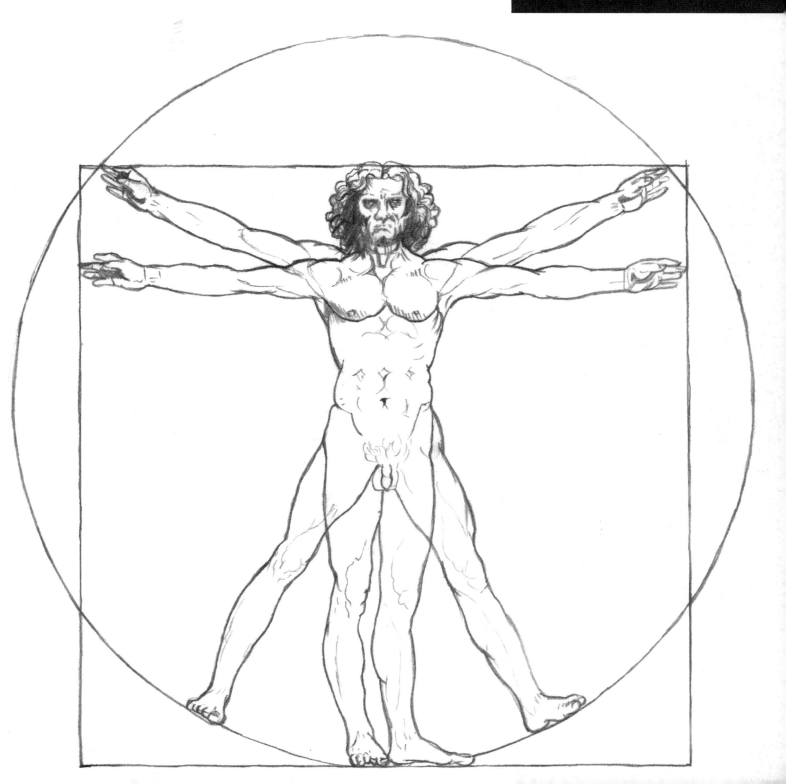

A life drawing in the style of Leonardo da Vinci's Vitruvian Man.

Materials

Equip yourself with a wide range of drawing tools, as different media allow you to work in different ways. Some materials are more suitable than others for certain tasks.

GRAPHITE PENCIL

The graphite pencil is a versatile implement and in the right hands becomes a precision tool. They are available in a wide range of grades, but be aware that they can vary in quality. Cheap pencils can produce a gritty line and break easily, so always use a good quality brand. It is an inexpensive tool and a wise investment.

There is no lead in a pencil and it is a misnomer to call it a 'lead pencil'. A combination of graphite dust and clay make up the 'lead'. A very hard grade pencil, such as a 6H, is mostly clay with little graphite, whereas the soft 6B pencil is laden with graphite and will produce heavy dark lines that have a tendency to smudge.

For sketching, 4B, 2B and HB are the grades I most commonly use, but the range of hard to soft goes from 6H (the hardest) to 6B (the softest). However, the range does extend to 9B and drops as low as 9H. Many brand of pencils have a dark or coloured end, which is useful for measuring.

In order to have a wide ranging set of tools, sharpen your pencil tips in three different ways: fine point for detail; a dull point for general drawing, which allows you to erase if drawn with a light touch; and finally a pencil sharpened at a low angle to expose more of the tip. This is excellent for shading larger areas when holding the pencil on its side.

Use a craft knife to shape your 'leads' and if you require a really fine point, use a piece of glass paper or emery board. All tools eventually wear out, so once a pencil becomes too short, discard it.

Also available are graphite blocks or sticks of pure graphite. These are excellent for smudging and blending tones and are available in grades from HB to 9B.

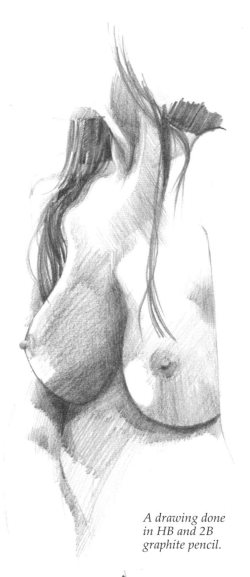

A drawing done in HB and 2B graphite pencil.

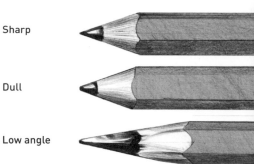

Sharp

Dull

Low angle

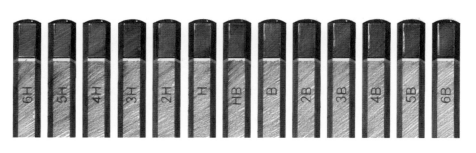

BALLPOINT PEN

I am referring to the common writing pen which can be purchased in large packs, very cheaply at discount stores. It is not an obvious drawing tool, but I love the freedom of using a ballpoint pen, as the pen tip glides over the paper surface. It is particularly good for quick, loose sketches, but I also enjoy using ballpoint pens for more controlled and detailed works. There is no going back with a ballpoint, as it cannot be erased and is a test of your mettle.

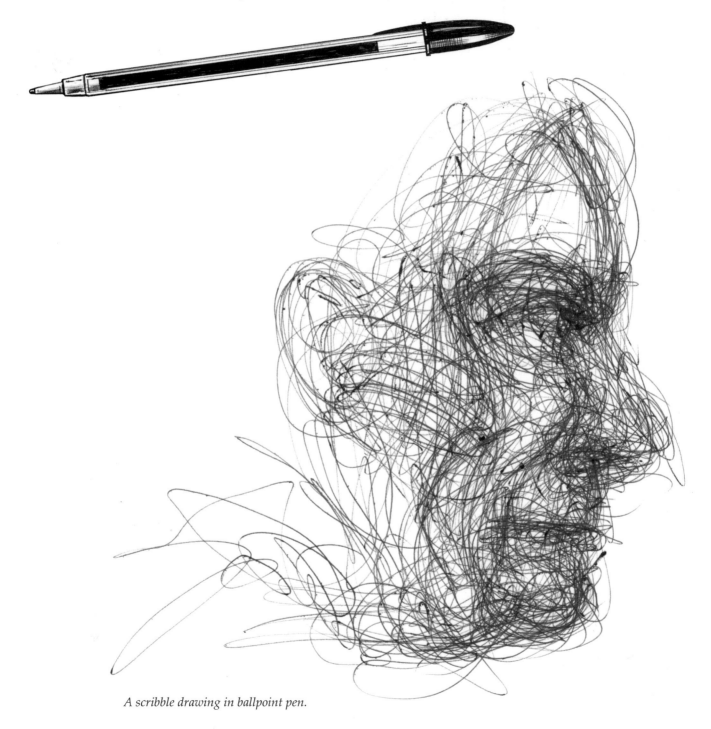

A scribble drawing in ballpoint pen.

WAX CRAYON

Wax crayons can be bought from art shops, but a child's crayon also does the job a little cheaper. An advantage of the wax crayon stick is that your drawing does not require fixing. Again, they are suitable for quick sketching and dark, contrasting images. The wax cannot be erased, but can be dissolved with lighter fuel for effect. Beware that wax crayons melt if left in direct sunlight as I discovered in Tuscany one hot sunny day!

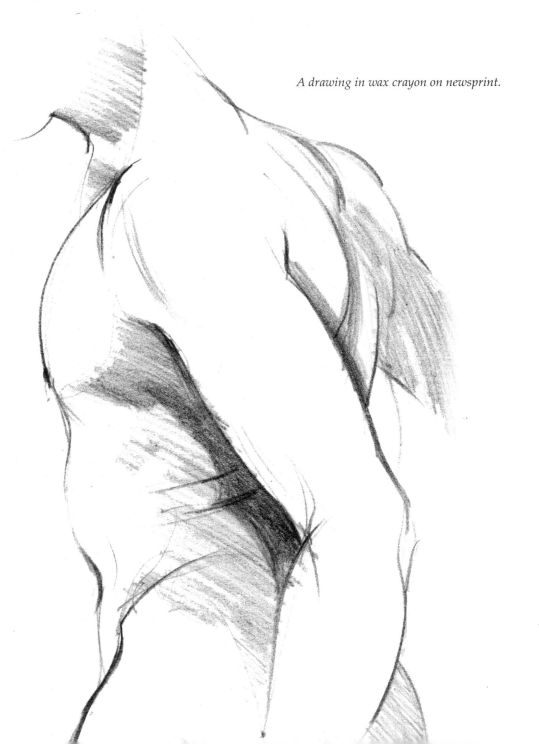

A drawing in wax crayon on newsprint.

CHARCOAL STICKS

Charcoal is made from carbonized lime, vine or more commonly willow twigs. The sticks come in a range of sizes from very thin to thick chunks and they are graded hard or soft. You can cover larger surface areas very quickly with charcoal and it is especially good for capturing tone. You can use a hard eraser to draw into the charcoal to pick out highlights and a kneaded putty eraser to lift off unwanted charcoal. In the absence of an eraser, apparently a piece of soft white bread will do the trick.

Compressed charcoal, which produces a much darker and deeper line, is available as a block or in pencil form.

Willow charcoal and (right) compressed charcoal.

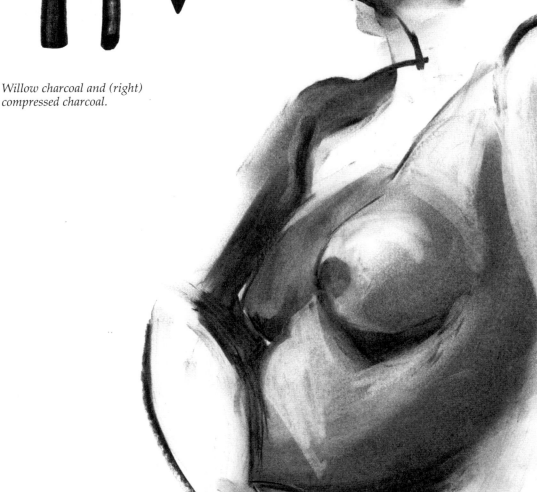

A drawing in charcoal.

PAPER

In general it is better to avoid coated papers as uncoated papers are more suited to the various media we use. The choice of paper is important and will influence your drawing technique, for instance whether it is rough or smooth, so experiment with different paper surfaces.

Inexpensive newsprint paper (fish and chip paper) is excellent for wax crayon as it is uncoated but has a slight sheen, enabling the wax crayon to glide over the surface. The disadvantage with newsprint is that it discolours over time, but is ideal for quick warm-up poses. The paper surface does have a tendency to ripple depending on the humidity, but if you have produced a drawing worth framing, you can always mount it, which will smooth out the paper. Newsprint is not suitable for pencil or charcoal.

Wax crayon on newsprint paper.

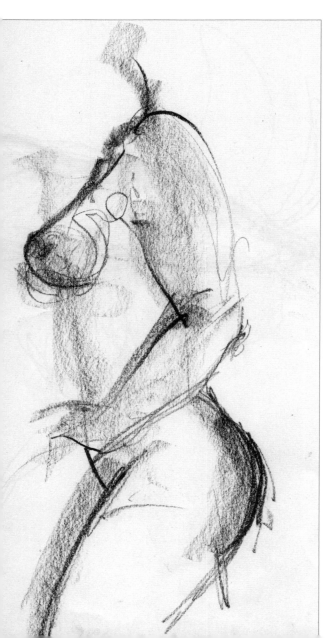

Cartridge paper is uncoated paper of a weight between 150–300gsm (70–140lb). It is acid free and made from rags, wood or certain kinds of grasses. Originally it was used in the production of paper cartridges for firearms. You can get cartridge paper in smooth or rougher finishes. A smooth-surfaced cartridge paper responds well to compressed charcoal, enabling you to produce subtle tones by smudging the charcoal with your finger or the palm of your hand. It does not work so well with charcoal sticks, but a rougher cartridge paper with a bit of a bite takes both charcoal and graphite block very well.

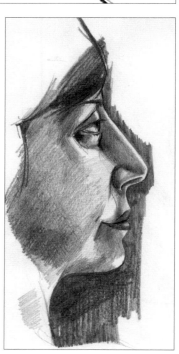

Pencil on smooth cartridge paper.

If you are likely to use large quantities of paper, contact your local paper mill. A ream (500 sheets) would be the minimum quantity sold, and the paper is untrimmed, which gives you a slightly larger sheet. I have always found paper suppliers very obliging and the cost per sheet is a considerably less than in an art shop. Remember to ask for uncoated papers.

Graphite block on rough cartridge paper.

SKETCHBOOKS

The size of a sketchbook will determine the way you work, so try not to use one that is too small. I prefer an A4 spiral-bound pad, with 150gsm (70lb) smooth cartridge paper. This is perfect for drawing with either pencil or ballpoint pen. Make sure that the pads have a substantial backing board for both support and protection. These are available from specialist art shops and some stationers. All the drawings on this page were done in pencil in a smooth cartridge paper sketchbook.

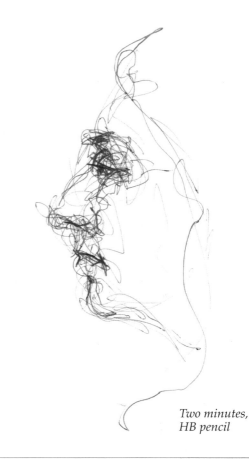

Two minutes, HB pencil

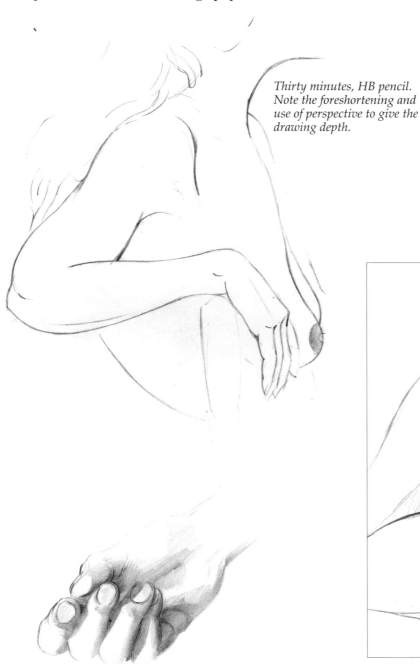

Thirty minutes, HB pencil. Note the foreshortening and use of perspective to give the drawing depth.

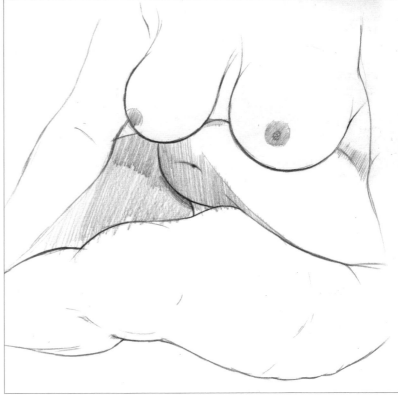

One hour, HB pencil

Thirty minutes, HB pencil. The variation in the line weight helps define the form and give the body substance.

OTHER MATERIALS

Drawing is a relatively inexpensive pursuit but you will need a range of support items to make your life easier. All of the following can be bought from specialist art dealers, but some items can be found in stationers and DIY stores.

Hard eraser Apart from rubbing out, this kind of eraser, as opposed to the putty eraser, can be used as another drawing tool. I use the hard eraser when working in charcoal or soft pencil either to smudge or to 'draw' in a highlight.

Fixative It is thought that hairspray is a cheap alternative to artist's fixative, but I find that it can discolour a picture over time as it reacts to the paper, so if you have a drawing that you want to keep, use the real thing.

Drawing board I have a number of thin plywood boards cut to different sizes to take on drawing expeditions. These are considerably lighter and cheaper than an artist's drawing board. Your local DIY store may even cut a sheet of ply to size for you.

Paper stump A rolled-up piece of blotting or cartridge paper, shaped to create a point, used to produce fine detail in charcoal or soft pencil by gently rubbing and teasing out soft tones.

Scalpel or craft knife Avoid pencil sharpeners, as they will eat your pencil and produce only one kind of point. By using a scalpel or craft knife, you can customise your pencil to expose more lead for shading or make a fine point for detail.

Masking tape For attaching paper to drawing boards. Apart from the standard masking tape, you can also buy a low- tack masking tape that will not damage the paper surface when removed.

Lighter fuel This was once readily available, but you can now only buy it through art suppliers and some DIY shops. It is good for cleaning paper surfaces and removing grease. It is also useful to lift off stubborn pieces of masking tape without marking the paper surface. As a creative tool, experiment by using the fuel to dissolve wax crayon or ballpoint pen to create tone in your drawing.

Kitchen paper This can be used for lifting off unwanted charcoal or rubbing the charcoal to create tone in a drawing.

Small paintbrush Rather like the paper stump, you can use a small flat-ended paintbrush to work on fine detail and to tweak charcoal into shape.

Easels The traditional portable wooden easel requires a sharp mind, an adept hand and all the skill of a deckchair seller to erect it. It also needs an added safety feature: a length of string! Once the easel is erect, tie the string around the three legs so that they do not splay out in all directions once you start to work. For working on location, I prefer the metal tube style easel, as they are light and do not have the problem of legs drifting apart.

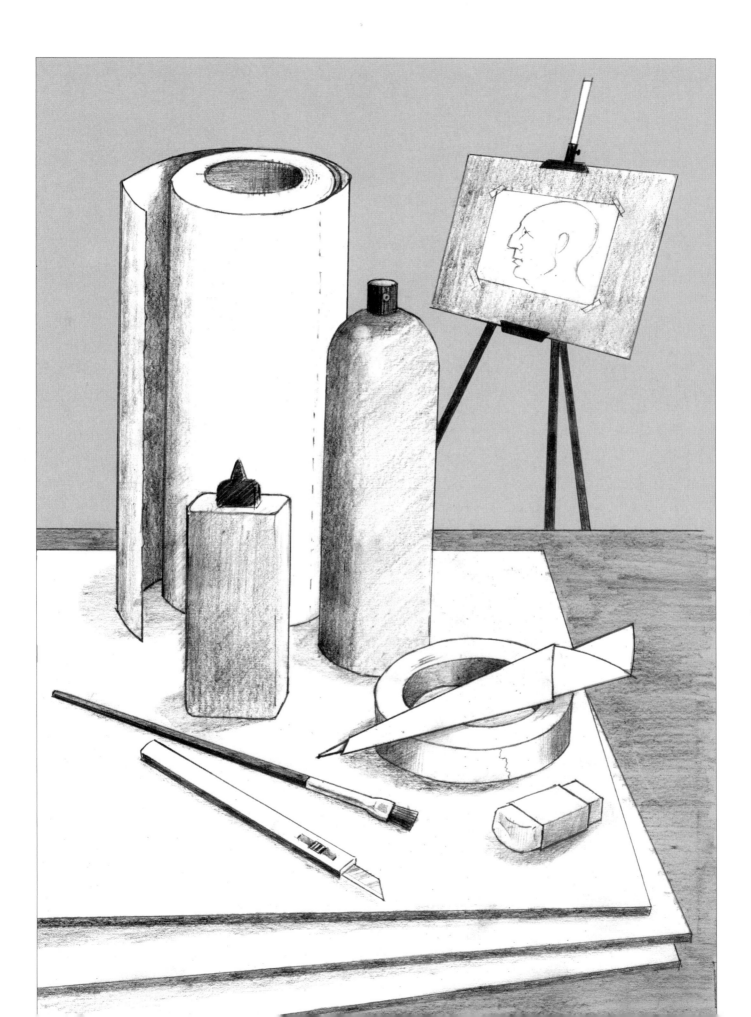

Starting to draw

Drawing is the most direct way to convey an idea or emotion and has been used as a form of communication since man first walked the earth. Therefore we are all capable of drawing to some degree and our brain can interpret even the most basic matchstick men as representing the human form.

Some people have a better understanding of drawing than others and are able to represent our three-dimensional world within a drawing, but we can all learn how to draw by applying some basic rules. There is no better place to start to develop your drawing skills, than a life drawing class.

Earlier I mentioned the importance of working with a good life model, but you also need take in to account the lighting – whether you are working with a flat, even light, as produced by overhead fluorescent lighting, or a directional light such as a spotlight, or natural light from a window. Directional lighting will create shadow and contrast and emphasise contours.

The distance you are from the model is also a consideration. If you are sitting only a matter of feet away, this is good if you want to draw a detail or concentrate on a small area of the body, but not ideal for drawing a full-length figure.

In a workshop environment, we discipline ourselves to working with timed poses such as two minutes, ten minutes or thirty minutes. The constraints of working in this way will help you to focus and sharpen your observation. As you learn to pace yourself, you will build up a range of stylistic approaches to cope with these different situations.

Let's begin by looking at a simple pose, drawn over a fifteen-minute period. By 'simple pose' I refer to the fact that you can see the complete body with little foreshortening, and you are therefore able to see how the proportions relate to one another and get an idea how the body is constructed.

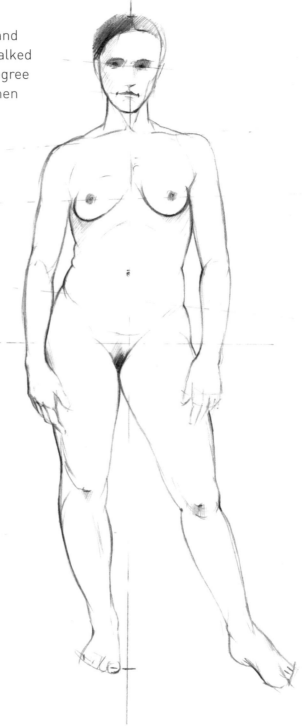

A Simple Pose

What follows is a demonstration of my thought process in order to capture the pose, from life, on to paper. Life drawing is as much about observation as honing your drawing skills, so before starting to draw, spend a few moments studying the pose and its characteristics – the angle of the shoulders, how the body's weight is distributed and any foreshortening. There is always an element of foreshortening in any pose, for example in this pose the right foot is seen face-on and foreshortened and the left foot also has a slight foreshortening.

There is a symmetry to the human form and we all have the same basic body proportions. Without getting too entrenched in Leonardo's theories and calculations, use the length of the head as a unit of measure and keep at the back of your mind that seven heads fit into an erect figure, and that the tips of the fingers dangle mid-way along the thigh when an arm is relaxed.

A

C

B

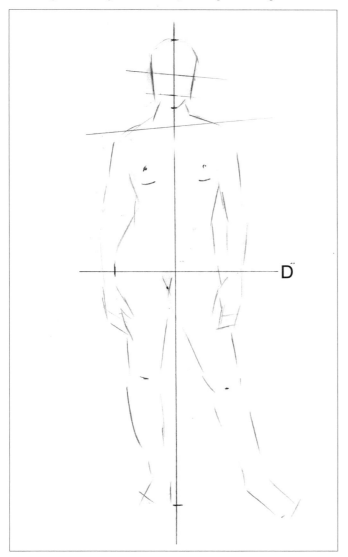

D

1 We need to anchor the drawing, placing it within our sheet of paper. Draw or imagine a central line vertically running through the figure. Next, place a mark to indicate the top of the head (A) and another at the foot of the drawing (B). The third mark (C) is the chin position and defines the size of the head, which in this upright pose, remember, will fit seven times in to the overall length of the body. By placing these marks on the vertical line, you have now fixed the drawing within the page and defined the scale, forming the basis of a grid to build upon.

2 Draw or imagine a second line running horizontally through the vertical line, halfway down (D). This halfway point lies just above the pubis region (the lower front of the hip bone). Your grid is now complete and you can start to construct your drawing. I have also added further guidelines indicating the angle of the shoulders and the facial features. Lightly draw in the remainder of the figure by placing marks at key points and joining them up. Use your eyes to measure, not a ruler. Do not draw in any features yet. Check that you have not drawn the head or shoulders too narrow or too wide by comparing the width against your unit of measure – the length of the head.

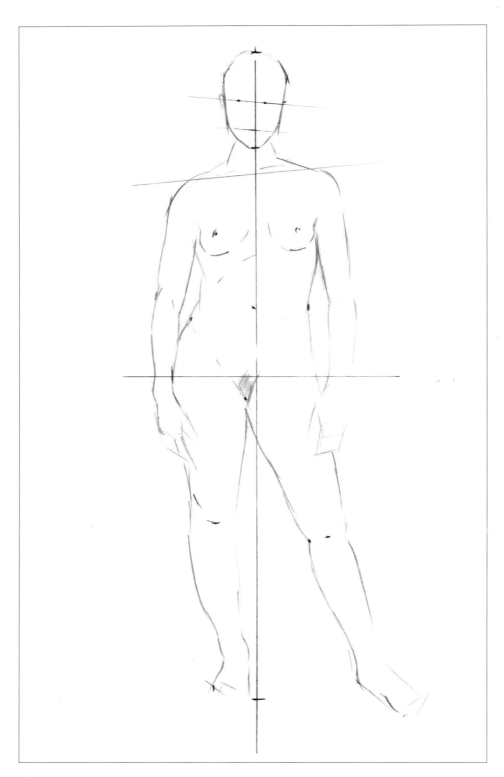

3 Work over the whole drawing, adjusting and measuring as you proceed. This construction method of drawing enables you to amend as you progress before committing.

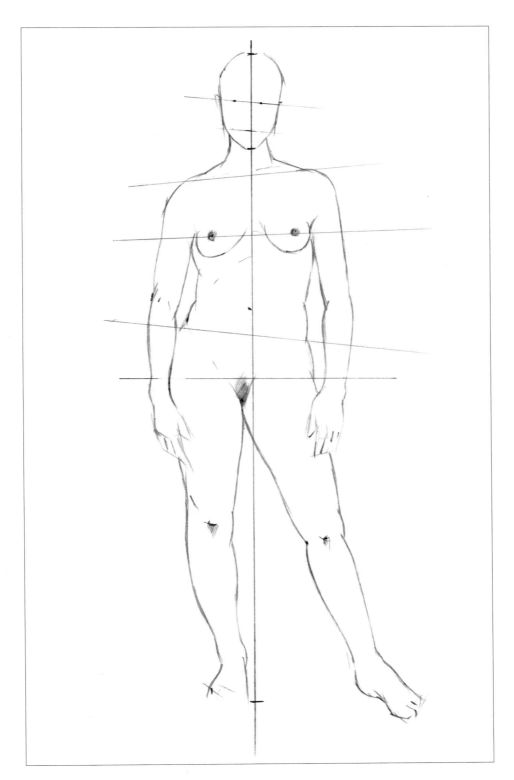

4 Once you are satisfied with the drawing in terms of composition, start refining your line and be aware of even the slightest contours in the body. Use the vertical line as a guide to check, for example, how far the knees are from the line.

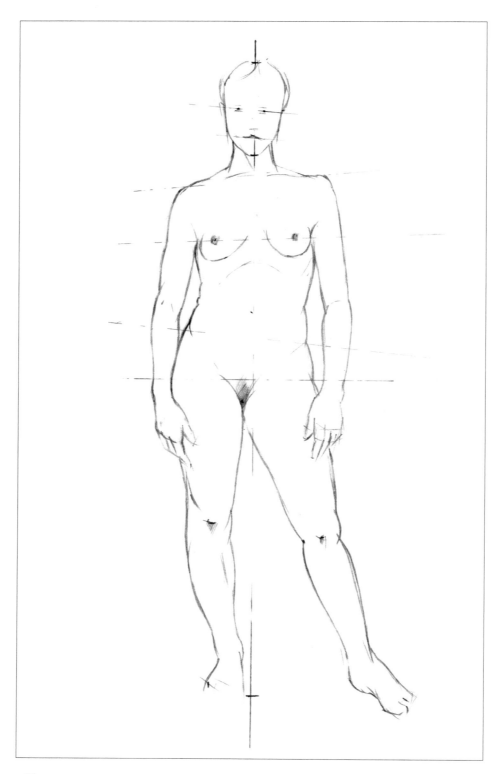

5 When all is looking correct, bring the drawing to life by strengthening your line and suggesting form. For example, to give the breast weight, I have used a heavier line, and I have also drawn heavier lines at the points of tension.

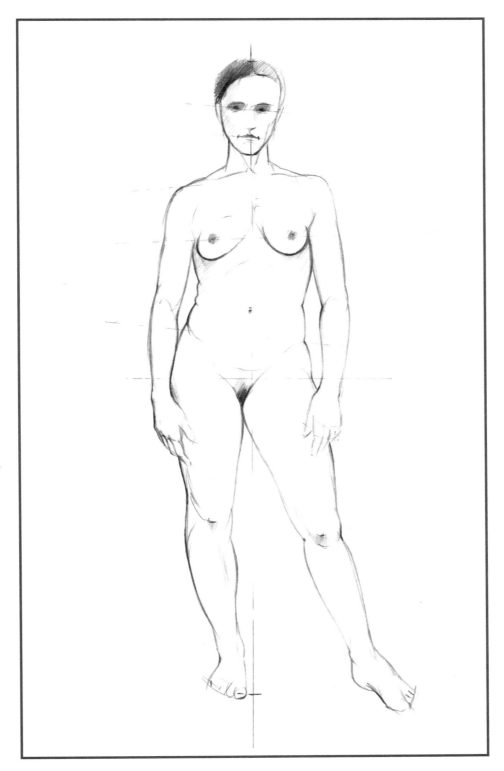

The finished drawing

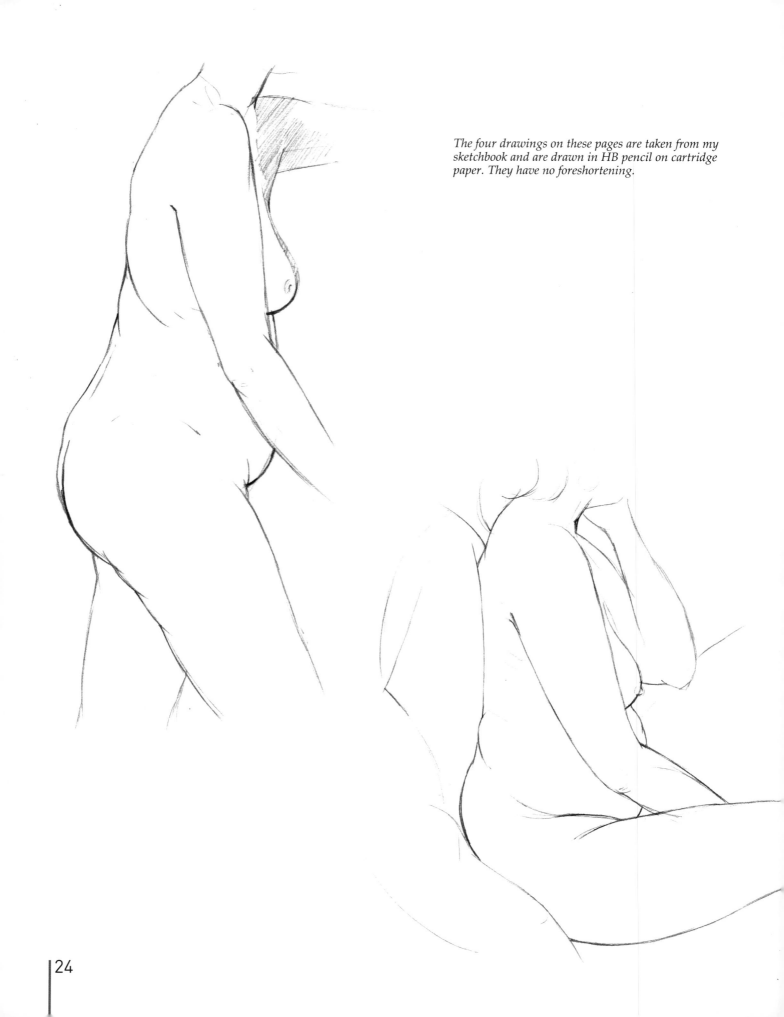

The four drawings on these pages are taken from my sketchbook and are drawn in HB pencil on cartridge paper. They have no foreshortening.

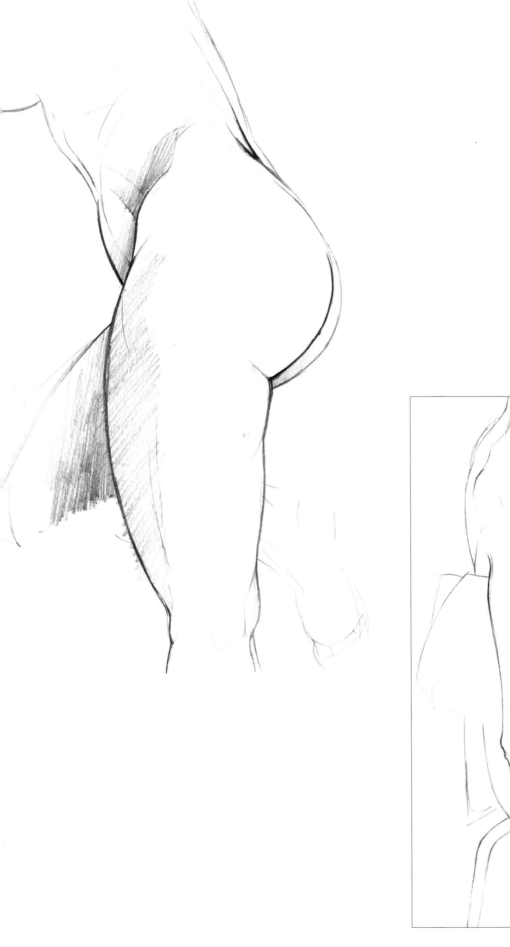

Gesture drawings

Gesture drawings are sketched out in short bursts of energy lasting no more than one or two minutes. Working fast with your eyes fixed on the model and the occasional glance down at your drawing, you try to record as much information as you can relating to the pose – the angle of the body, foreshortening and how the body's weight is distributed, in order to capture the essence of the gesture in the limited time that you have.

Gesture drawing is an exercise to sharpen your powers of observation. Do not consider what you are drawing; the aim is to react to the model intuitively and not to give your mind a chance to ponder. It is about the triumph of the right half of the brain over the dominant left half. The resulting drawing will contain a vitality and energy different to a work drawn over a longer period of time.

As long as you remain focused, there are no 'mistakes' in gesture drawing. With each pose you are learning a little more about the body and how it functions, and you might get one or two interesting drawings as a result.

The gesture drawing is an excellent limbering up exercise and I always begin workshops with five two-minutes poses. It helps you understand form through challenging and unusual poses.

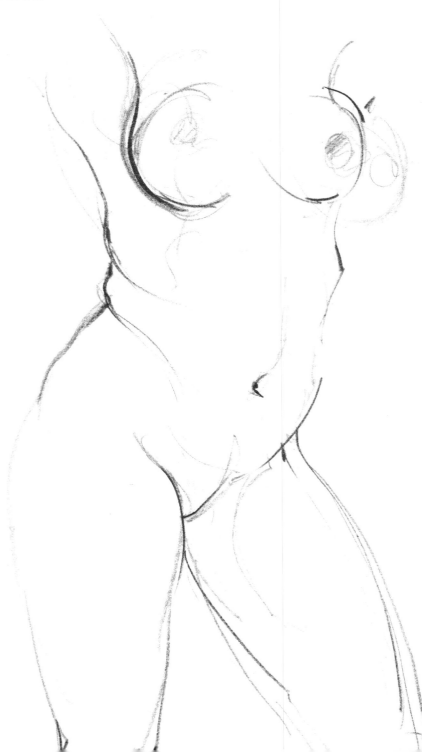

Wax crayon on newsprint.
Note that the drawing has been
amended as the model either
moved or I had second thoughts.

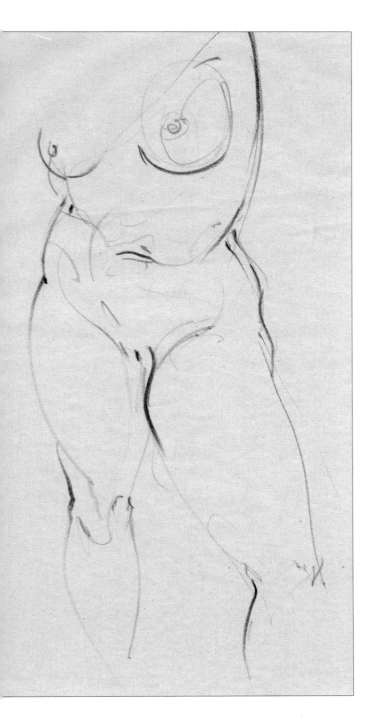

Examples of gesture drawings done in one or two minutes. Above: wax crayon on newsprint. Right: ballpoint pen on smooth cartridge paper.

THE METHOD

Ideally you should work with an experienced life drawing model. Good models can hold physically demanding poses, but only for a short time, so you need to work fast. Have you ever tried holding your arms above your head without moving for two minutes?

Failing this, the discipline of carrying a sketchbook will allow you to practise this kind of drawing while out and about, catching the public in restaurants, bars or train stations. Be warned, you will not get as long as two minutes as people rarely remain still.

Work all over the page, sketching in the whole form so that you establish the drawing within the page. You do not need to worry about detail or include fingers and facial features; remember that you are focusing on the gesture and capturing the essence of the pose. Do not be afraid to rework your drawing, adjusting your line, and pulling the drawing into shape. Work very lightly until you are confident about the position of a line and then give it some weight. Employing different weights of line will give the drawing depth and accentuate the form.

Using different media forces you to work in different ways. Any medium can be used, but I prefer either graphite blocks, wax crayon or a ballpoint pen, as they glide easily over the paper surface.

The larger you draw, the more control you have over the image and this avoids too much scaling down from what you are seeing in front of you to a small piece of paper!

Work with your drawing board upright or at least at a steep angle. If you work flat on a table or on your lap, picture distortion is more likely to take place as your eye is seeing information on one plane and then transposing it to another.

Wax crayon on newsprint.

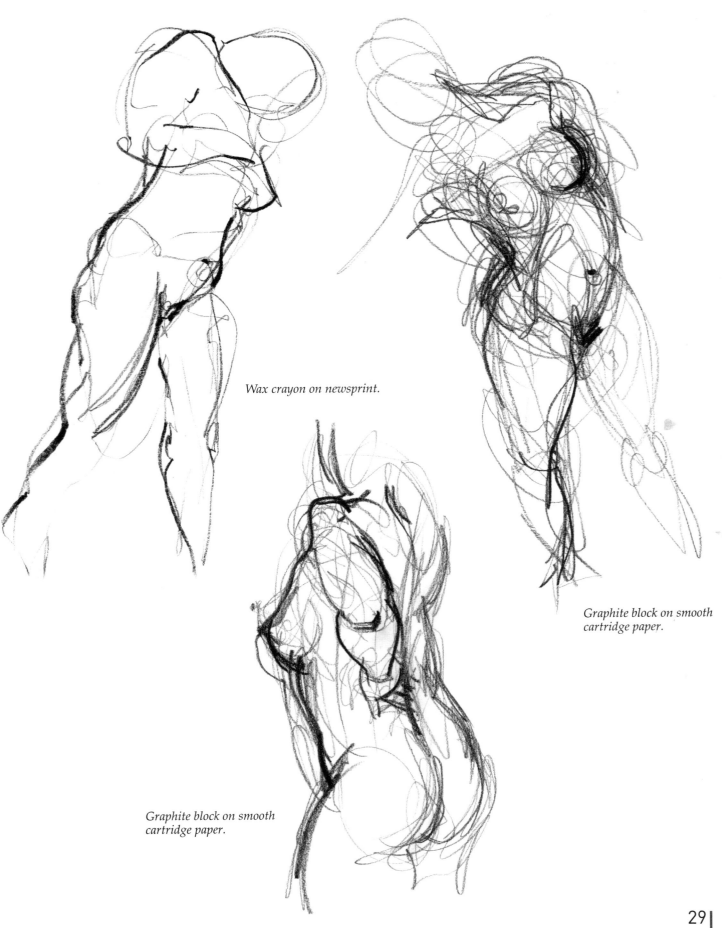

Wax crayon on newsprint.

Graphite block on smooth cartridge paper.

Graphite block on smooth cartridge paper.

29

Line

'Drawing is an exploration of the Form.'
Slade School of Fine Art motto

A common fault when drawing in line is to represent the model as little more than a silhouette, or to use bold, consistent lines, making the drawing look flat, with no real form. To bring your drawing to life, you need to use not only a light touch, but also a variation in the weight of the line to give the drawing depth and a three-dimensional quality. It is through line that we can begin to understand the body's form and its subtle contours.

During the early days of London's Slade School of Fine Art (founded 1871), figure drawing was at the core of the school's teaching. Under the direction of tutor Henry Tonks, students flourished. Augustus John and William Orpen were both star pupils. Tonks believed that until a student understood the underlying structure of the body, they could not portray the human form accurately. His students were taught to draw in line rather than tone and were encouraged to make corrections by reworking the lines rather than using an eraser. The poses tended to be short.

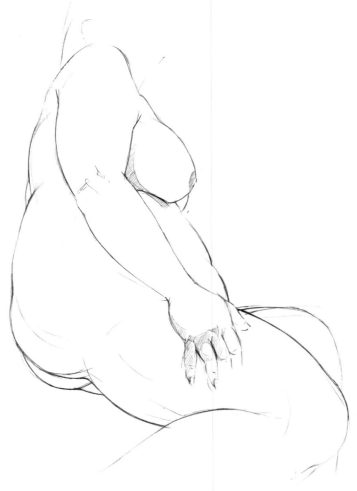

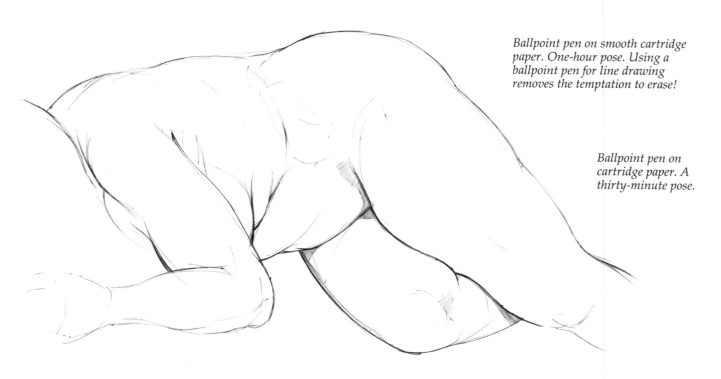

Ballpoint pen on smooth cartridge paper. One-hour pose. Using a ballpoint pen for line drawing removes the temptation to erase!

Ballpoint pen on cartridge paper. A thirty-minute pose.

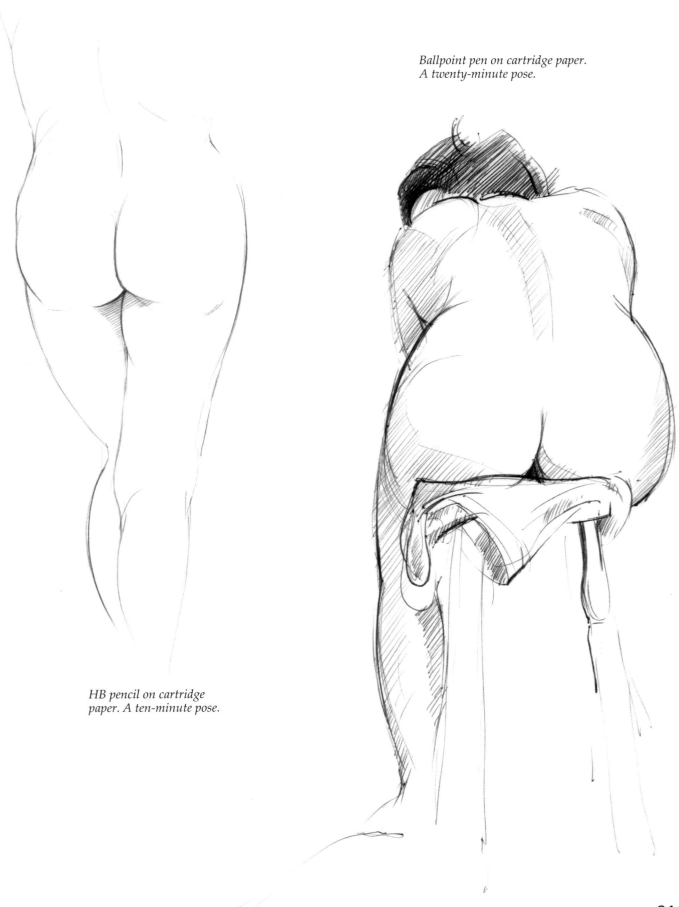

Ballpoint pen on cartridge paper. A twenty-minute pose.

HB pencil on cartridge paper. A ten-minute pose.

AN EXERCISE IN LINE

In this exercise we will take the Slade's motto and Tonks' reasoning as our maxim, and explore the form through line to capture the body's weight and muscle tension. This is achieved by varying the weight of your drawn line through differing pencil pressures. In the final stage of this drawing, I have drawn the muscle contours by using a concentration of softly draw lines.

The following exercise is typical of a thirty-minutes pose, and I used an HB pencil on cartridge paper. The model is in a 'simple' pose with little foreshortening. The lighting in the studio was flat (overhead fluorescent lights) to avoid too much tonal contrast, allowing me to observe the gentle body curves. To help get a clearer understanding of the model's silhouette, I placed her in front of a dark background.

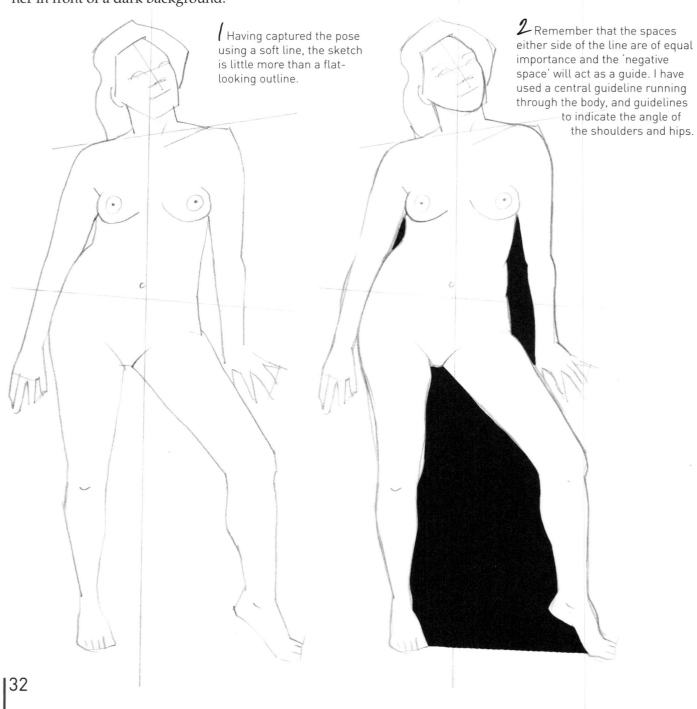

1 Having captured the pose using a soft line, the sketch is little more than a flat-looking outline.

2 Remember that the spaces either side of the line are of equal importance and the 'negative space' will act as a guide. I have used a central guideline running through the body, and guidelines to indicate the angle of the shoulders and hips.

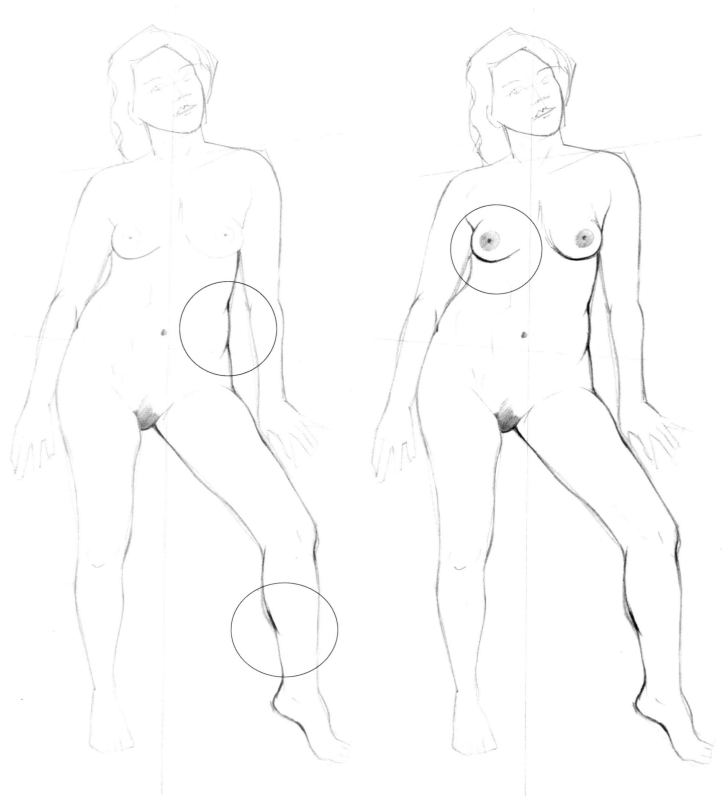

3 When drawing in pure line, it is easy to represent the figure as little more than a silhouetted shape with no real form. We are at the point in this drawing when we need to start indicating muscle tension and to create this, use a variation in the weight of your line at the points of tension (shown circled).

4 You can suggest weight, as in the breast, also by using a heavier line. Whatever your choice of medium, practise drawing with a light touch and a varied weight of line,

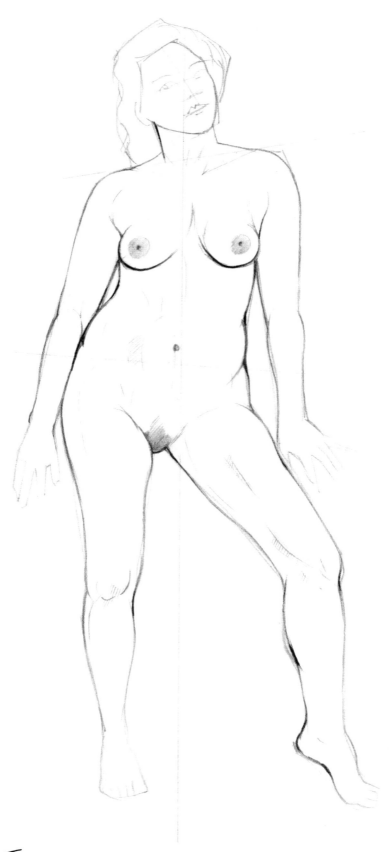

5 Next begin to indicate the muscle and contours of the body in gentle line. Do not be afraid of reworking the line and correcting your drawing.

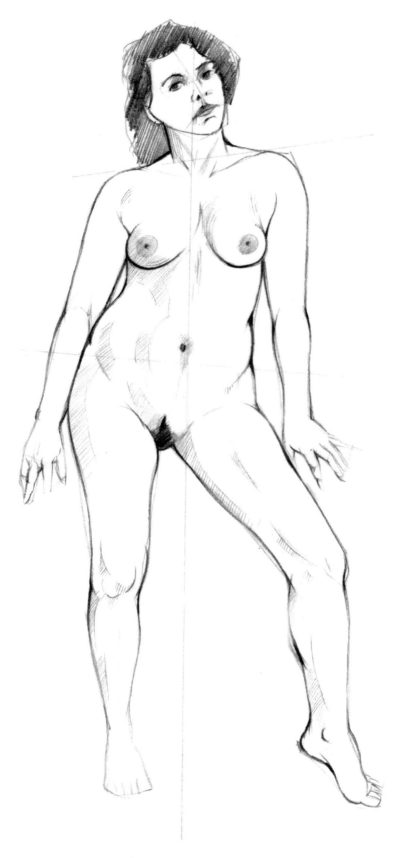

The finished drawing.

The rhythm of line

There are many approaches to life drawing and in order to develop your perception, experiment with different ways of interpreting the subject. This will give you a broad stylist repertoire to work with.

The rhythm of line is about looking for order in your drawing by creating interconnecting lines. For example, the contours of the body or a shapely curve are the points of focus, as in the exercise on pages 38–39. Step 2 shows how one part of the body can interconnect with another in a single continuous line, creating both harmony and rhythm in the drawing. Although it can appear a little stylised, this kind of drawing does have an energy and rhythm to the line.

The technique is not about spontaneity because we are thinking in a controlled way, very much as a designer would; design is about problem solving and creating order, and that is precisely what we are doing in this exercise.

The wax crayon drawing below is a good example of how I use this approach for a quick pose. Further examples are shown from my sketchbook and illustrate the same principle, that I have drawn the line to accentuate the body's surface contours and imply the muscle tone beneath.

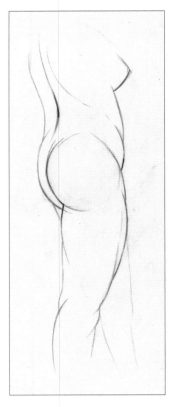

This is a simple ten-minute pose, but the underlying muscle is implied. HB pencil on cartridge paper.

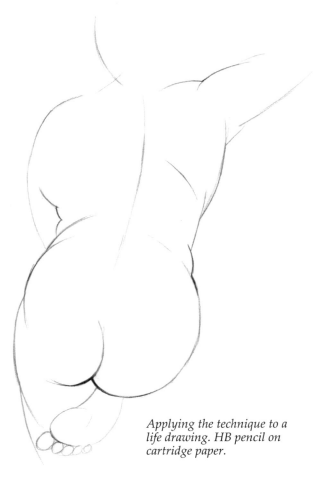

Applying the technique to a life drawing. HB pencil on cartridge paper.

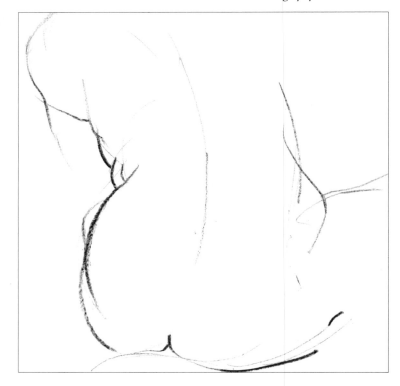

Here I have tried to capture the essence of the pose in a few lines. A five-minute pose. Wax crayon on newsprint.

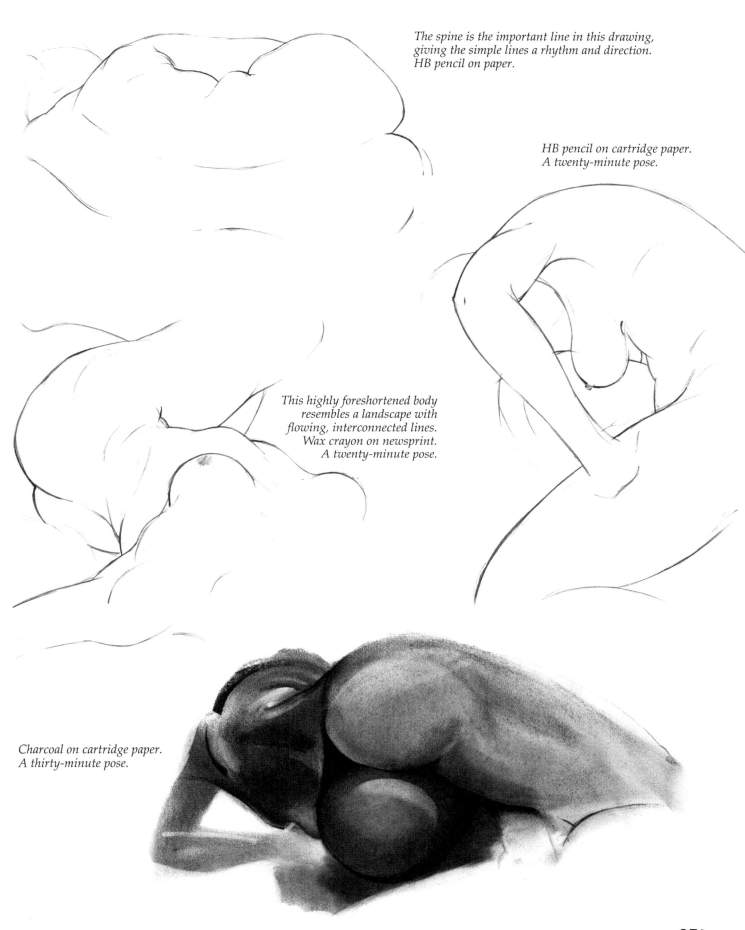

The spine is the important line in this drawing, giving the simple lines a rhythm and direction. HB pencil on paper.

HB pencil on cartridge paper. A twenty-minute pose.

This highly foreshortened body resembles a landscape with flowing, interconnected lines. Wax crayon on newsprint. A twenty-minute pose.

Charcoal on cartridge paper. A thirty-minute pose.

37

AN EXERCISE IN THE RHYTHM OF LINE

This is an exercise in line drawing and more particularly how the flow of the line accentuates the contours of the body surface and implies the underlying muscle action. This drawing was produced with an HB pencil on a smooth cartridge paper, and so that you can understand the process I have lightly drawn in the completed pose (right).

This book has been dedicated to observing and drawing from life, but this technique has also lead us to a point where we are now able to depart from pure observation and begin the process of abstraction. By stepping away from reality and using some imagination, you can experiment with the lines and the form to create something a little different!

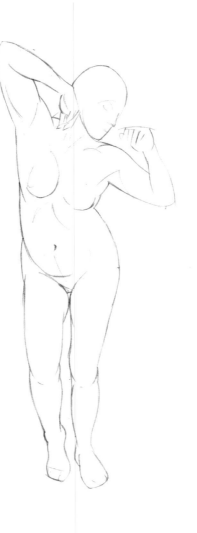

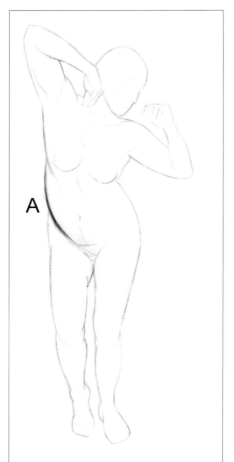

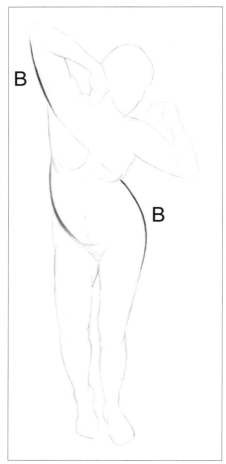

1 The first mark you need to make on the blank sheet of paper captures the beautiful curve of the lower torso (A).

2 The next line (B) flows in a single sweep from the upper right arm to the left hip, creating a gentle 'S'-shaped line. This is a perfect example of how one part of the body relates to and interacts with another, creating a rhythm to the line.

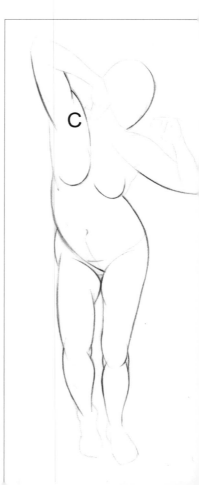

3 Continuing in the same fashion, notice how the muscle of the right shoulder (C), relates to the right breast below. Observing the relationship between one line and another in this way helps to produce an overall harmony to the form.

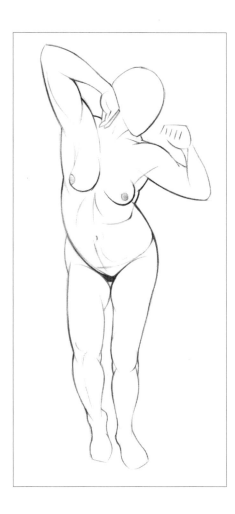

4 Build up the drawing by adding muscle and body details. Use a variation in weight of the line to give the figure substance.

5 Use the torso as the basis for the next drawing. By accentuating certain lines and discarding others, begin the process of abstraction. This is a pure left-side-of-the-brain exercise, as we try to create order and design into the work.

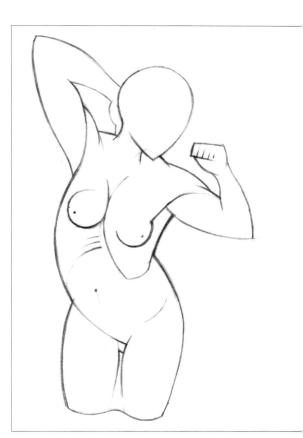

The finished drawing

Applying tone to suggest form takes the drawing into a new dimension. The finished result is a much more stylised image and could be used as a working drawing for a painting or sculpture.

As Oscar Wilde said, 'No great artist ever sees things as they really are. If he did, he would cease to be an artist.'

39

Tone

Tone represents how much light falls on a subject and its surrounding area and is not to be confused with colour. Tone helps to give the impression of volume in the subject and creates depth when applied to a drawing. The use of tone can also be a means of expression to suggest mood and atmosphere. An example of all these points can be found in the drawings of the French Neo-Impressionist painter, Georges Seurat (1859–1891).

Seurat drew in a very controlled manner using pure tone to capture form through light and shade, and without the use of line. His drawings, like his paintings, were carefully considered, with little spontaneity, but the results were always dramatic and striking. 'Seated Boy With Straw Hat', drawn in conté crayon in 1882, is an example of Seurat's use of pure tone.

Tone can be achieved in different ways depending on which medium you are using. Charcoal is very popular for tonal drawings but all the other media produce tone or tonal effects, so experiment with as many as possible; you will get different results with each.

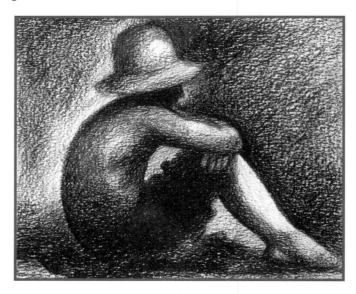

My version of Seurat's tonal drawing 'Seated Boy With Straw Hat.'

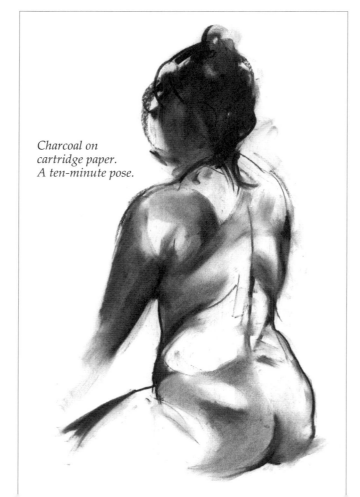

Charcoal on cartridge paper. A ten-minute pose.

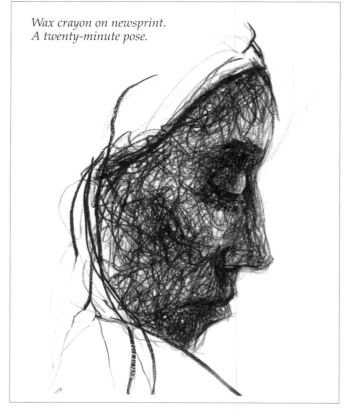

Wax crayon on newsprint. A twenty-minute pose.

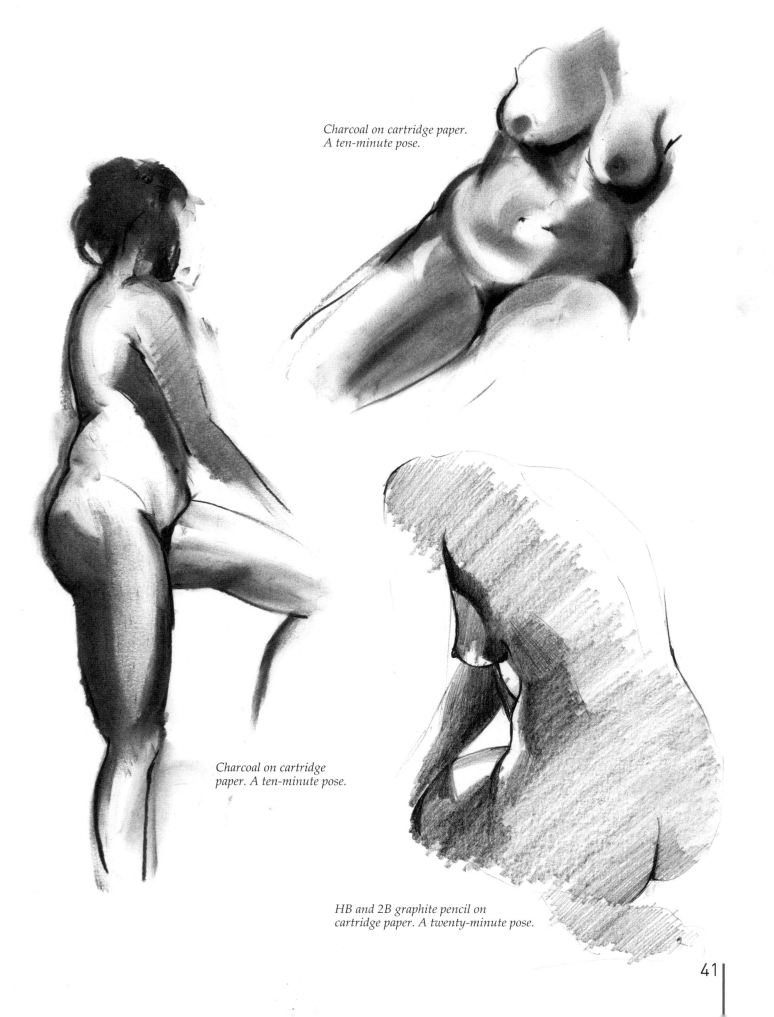

Charcoal on cartridge paper.
A ten-minute pose.

Charcoal on cartridge
paper. A ten-minute pose.

HB and 2B graphite pencil on
cartridge paper. A twenty-minute pose.

41

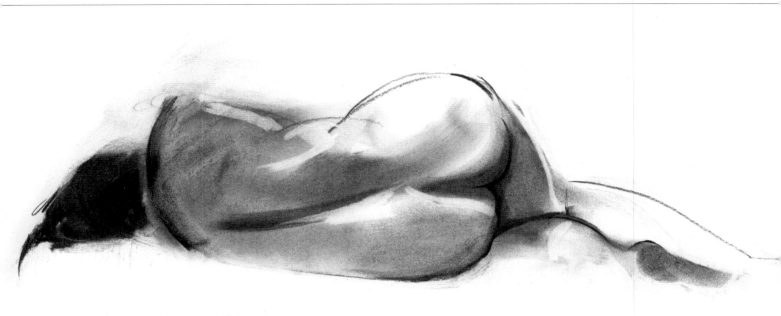

Charcoal on cartridge paper. A fifteen-minute pose.

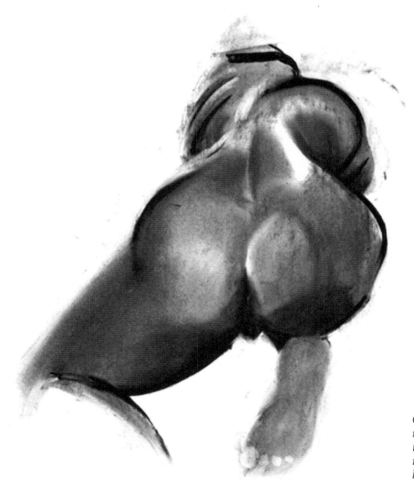

Charcoal on cartridge paper. A twenty-minute pose. Although drawn from life, this is also an example of taking the form into a more abstract drawing and not a literal impression of the pose.

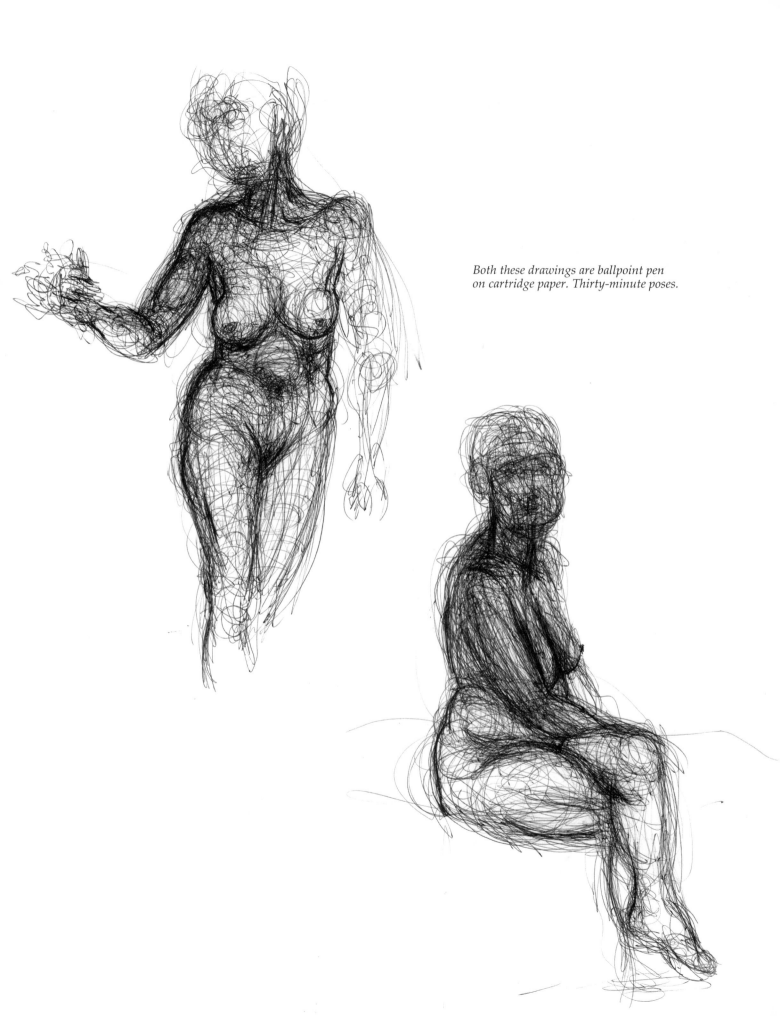

Both these drawings are ballpoint pen on cartridge paper. Thirty-minute poses.

SHADING TECHNIQUES

Graphite pencil

Creating tone with a graphite pencil works well over relatively small areas and your choice of pencil grade, whether soft or hard, will have a bearing on the depth of tone you can create. When shading a larger area with a graphite pencil, to get a better coverage, sharpen at a low angle so as to expose more lead. Hold the pencil at around a 45 degree angle, and use the side of the lead and not the tip to produce a graduated tone by scribbling quickly back and forth.

Here is an example of the tonal range that a 2B graphite pencil can produce, going from a solid through to a light grey.

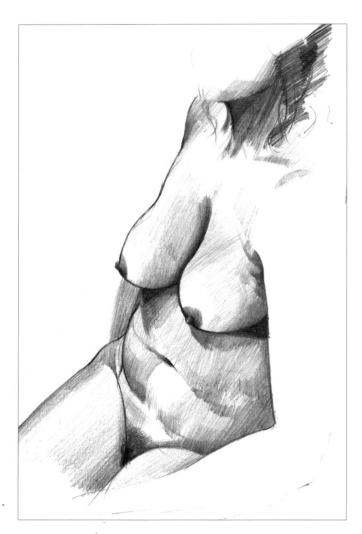

HB graphite pencil on cartridge paper. A one-hour pose. This line and tone drawing shows the range of an HB pencil.

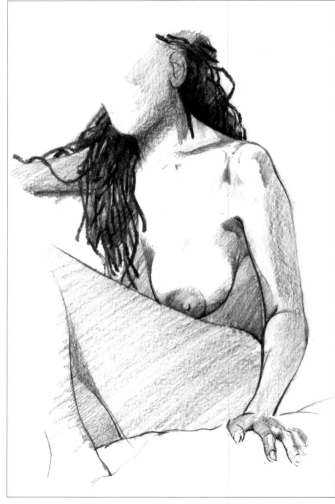

2B graphite pencil on cartridge paper. A one-hour pose. The tones produced by this 2B pencil are darker and a little grainier than the HB, as more graphite is deposited on the page.

Ballpoint pen and wax crayon

Using the harder media like wax crayon or ballpoint pen, remember that you are only creating the illusion of tone by using hard, solid lines against the white of the paper. With a softer medium like the graphite pencil, you are actually applying tone to the paper by the amount of graphite deposited on the paper surface.

The harshness of the ballpoint pen can be used to simulate a tonal effect by applying a cross-hatching technique (see right).

With a hard wax crayon I like to use either of two methods to give the impression of tone. The first, a variation on cross-hatching, is to scribble randomly over an area. The more concentrated the scribble, the denser the tone appears.

Cross-hatching with a ballpoint pen.

Scribble tone created using wax crayon in varying densities.

The second method, rather like the pencil technique, is achieved by holding the wax crayon at a slightly low angle and applying a quick back and forth motion, building up a concentration of the wax to create a tonal impression. By applying greater pressure, you make the tone darker.

 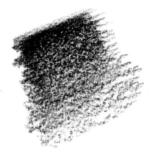

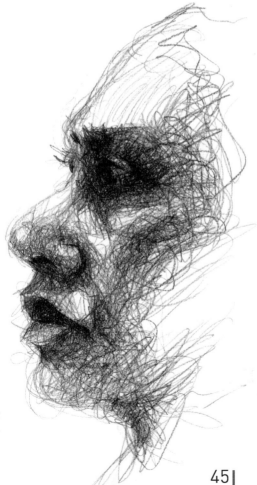

This tonal portrait of Dee in scribbled in wax crayon on newsprint paper. A thirty-minute pose.

A Tonal Study

I will now take you through a step by step of a life drawing made in pure tone in the manner of the Georges Seurat drawing. We are looking at tone without the use of line.

Use a hard wax crayon on either cartridge or a heavier grained paper. The response of the paper surface against the crayon is an integral part of this technique and so the rougher the paper, the more accentuated the granulated result.

How the subject is lit can be an important part of the composition. Use a bright light source, either natural (strong sunlight) or artificial (a spot lamp) to illuminate the figure. To create a dramatic image, direct a spotlight on to the life model to produce strong contrasting flesh tones. Depending on the angle of the light, you can pick out interesting contours along the body by the shadows cast.

Do not work on too large a scale; your choice of medium should always dictate the size that you need to work at. If you use this method on a very large format, not only will the grainy effect diminish, but the task will become monumental.

Draw using both the tip and the side of the crayon and apply fine tone by using a gentle, circular motion to get an even coverage, especially in the darker areas.

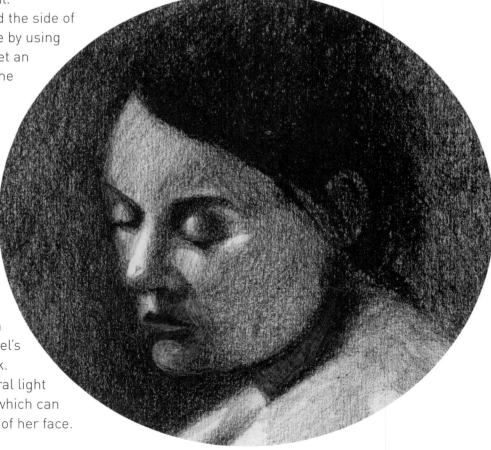

In order to accentuate the tones you are studying, narrow your eyes into a squint and you will see with greater contrast and clarity.

The step-by-step project shown here was a two-hour pose in wax crayon on rough cartridge paper.

The room was dimly lit and so to create contrast, I used a spot lamp pointed to the model's right, aimed towards her back. There was also a gentle natural light from the window behind her which can just be seen on the right side of her face.

A detail from the finished study.

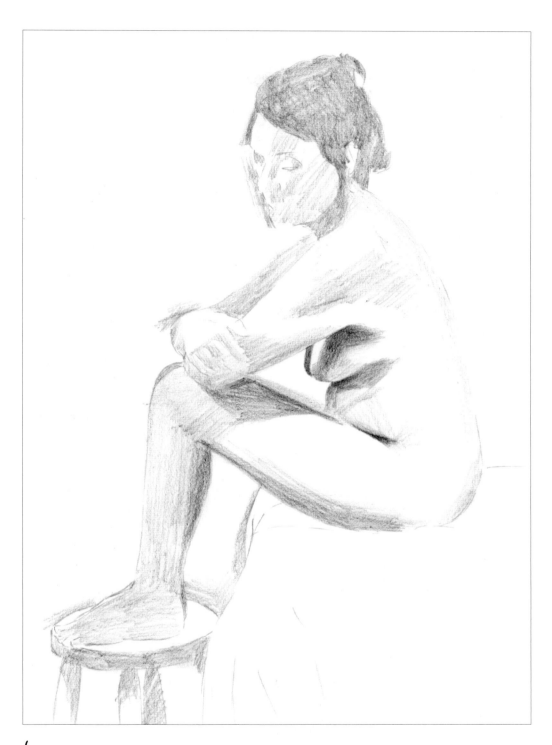

1 Lightly capture the outline and some key detail in tone, avoiding any hard lines.
I have used a very light touch with the wax crayon, but have already started at this early stage
to pick out the darkest areas and hardest 'lines', i.e. where the stomach rests on the thigh
for example. In general my marks follow the flow of the body and I am not too concerned with
getting a perfectly even tone, since as the work develops, the roughness will be disguised.

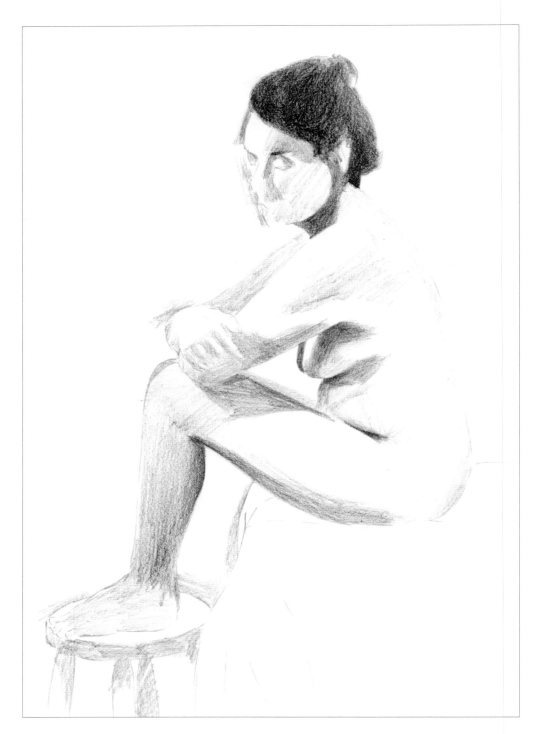

2 Once you are confident that you have everything in approximately the right place, start to strengthen your tones and develop the more prominent details. Use a light touch and an even pressure to reduce the chances of too much variation in the tone. The hair is the darkest area and so I have made steps to deepen the tone. I have applied heavier pressure to get a greater deposit of wax on the page, without committing to a solid black as yet. It is better that all the different tones develop together. Work on the leg and neck has continued and a hint of the background has started to appear around the forearm.

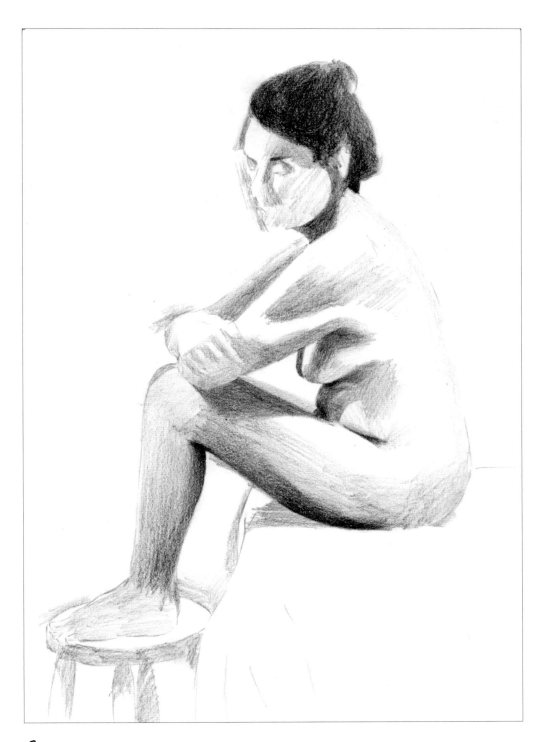

3 Decide which are the lightest and darkest areas of the model. To get a better idea, squint
your eyes and the contrast becomes exaggerated. In this pose, the lightest areas are the top of
the breast and parts of the face. The darkest are the hair and the shadows falling on the body.
Now draw in the darkest tone and begin to add the mid tones. The drawing will evolve if you
work across the picture, building up as you proceed. Do not start adding detail too early.

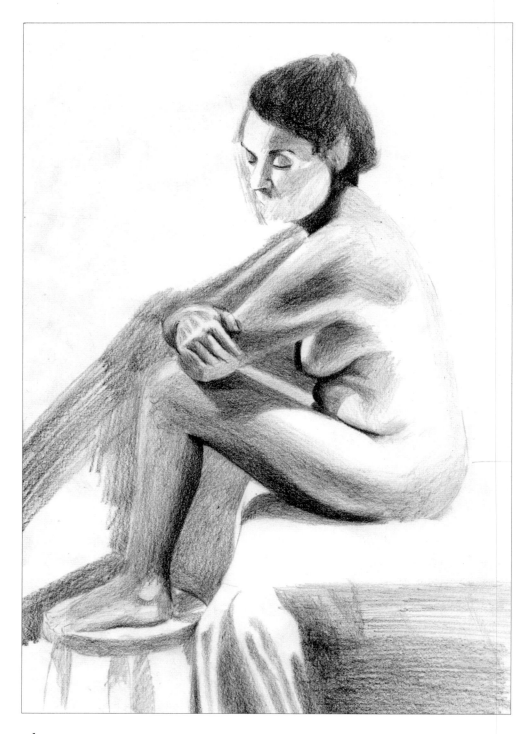

4 Some of the subtle tone differences and contours of the body are not apparent at first glance, but as your eye adjusts to the light, these subtleties become clearer. Be aware that during a long pose, the light will possibly shift and a variation in the strength of the light can occur if you are using daylight.

Draw in the darkest areas. In this study, they were on the underside of the leg. Taking the white of the paper as the lightest tone, you should now have a complete tonal range from light to dark.

The drawing is beginning to develop so hone in on specific areas. Here, the shadow on the top of the leg emerges as I use a gentle circular motion to apply the tone so as not to get hard lines.

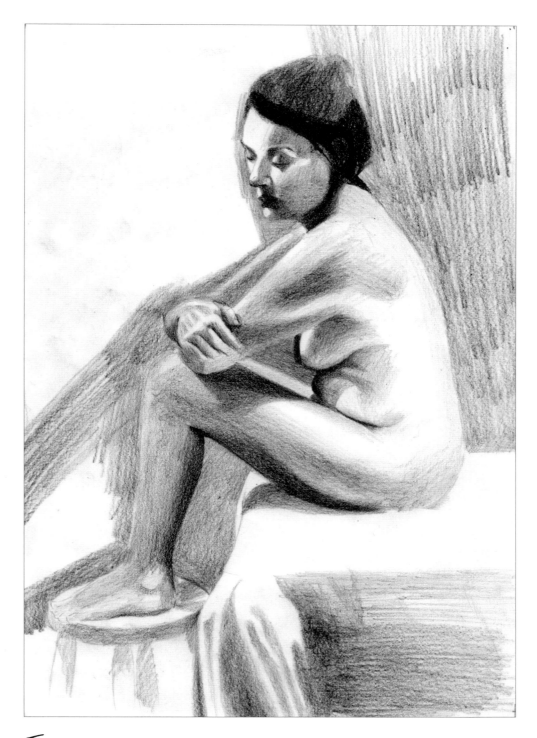

5 Add more of the background. Here, adding the dark background not only creates depth, but also throws forward the stark light of the highlighted table top and parts of the body. To restore the tonal balance, I darken the hair and add some detail to the face and mouth.

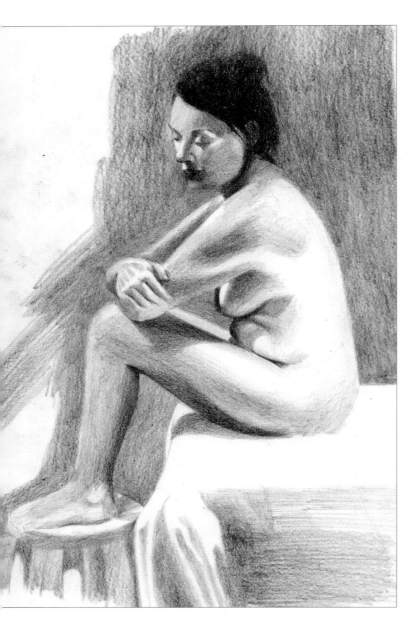

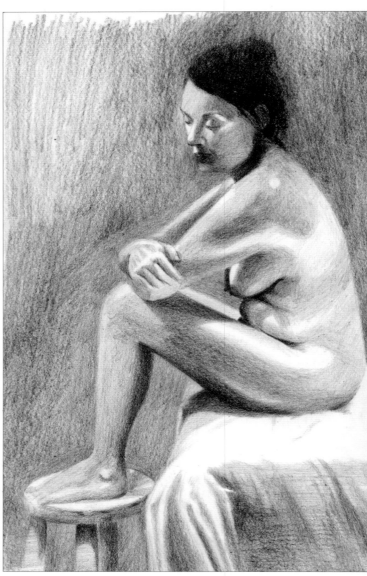

6 Rework the background using a light touch and a circular motion to create a smoother effect and disguise the initial roughly drawn marks. Work over the whole drawing, bringing areas to near completion. The hair is now finished and the stool beneath the model's feet is taken a little further.

7 The subtle tonal variations and the muscle form are beginning to appear. The background continues to develop and subtle detail is added to the chair and drapery. The body tones have also been worked on and you can see that I have created a highlight to the shoulder simply by darkening the surrounding area.

Opposite

The finished drawing. I had taken this drawing as far as I wished. The area around the mouth and neck had become too dark and overworked, so I removed some of the surplus wax with a sharp scalpel, and drew into the image with the tip of the blade. See the close-up detail on page 46.

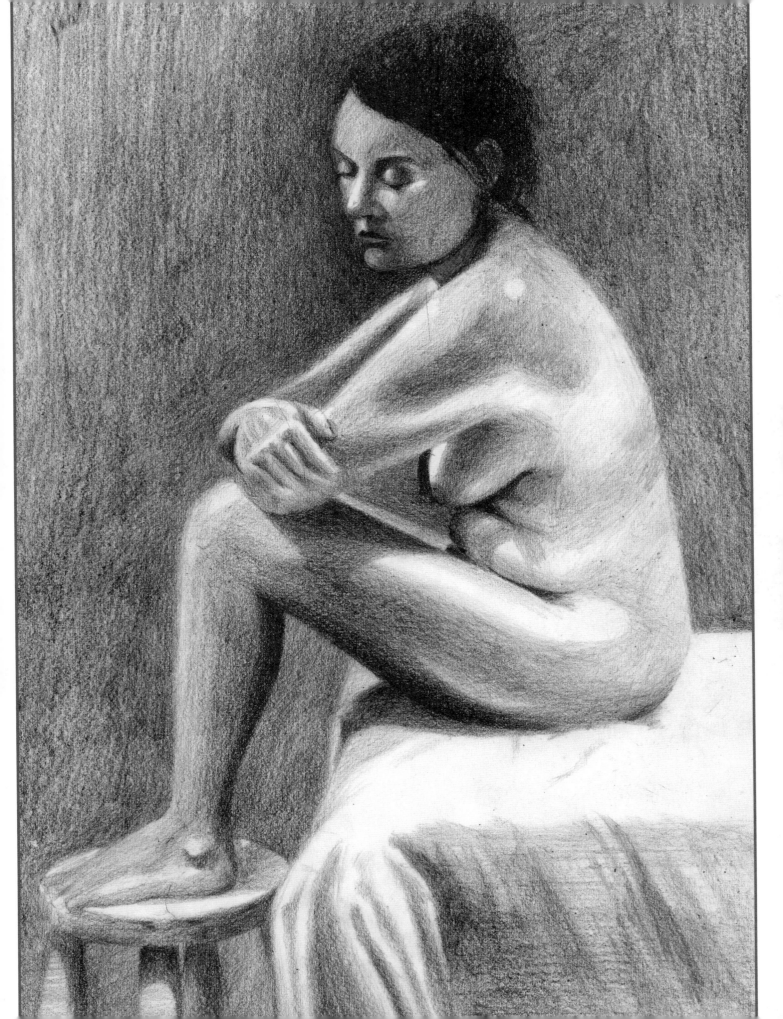

Scribble drawing

'Drawing is like taking a line for a walk.'
Paul Klee

I first started to scribble draw after seeing the sketches of the Polish artist Felix Topolski (1907–1989). He was a master of recording world events within a few scrawled lines, and his deceptively simple drawings won him the admiration of many. Adapting Topolski's 'simple' approach, I found the technique both liberating and adventurous.

We have seen how the technique of using only a limited number of strokes to capture the essence of a pose lends itself to quick gesture drawings (see pages 26–29). Now let's try scribble drawing for a longer and more controlled pose.

THE METHOD

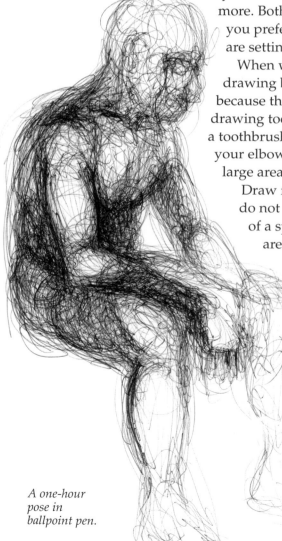

If you are using a wax crayon or graphite block, work on a larger format: A2 or more. Both these media allow you to draw quickly and cover a large area. If you prefer a ballpoint pen or pencil, work on a smaller scale, otherwise you are setting yourself a mammoth task.

When working on larger formats, always use an easel or at least prop the drawing board at an upright angle. This helps minimise visual distortion, because the drawing and the subject are on the same plane. Hold your drawing tool between your thumb and the tips of your fingers, as if holding a toothbrush, rather than a fountain pen. This will force you to draw from your elbow and shoulder and not your- wrist, giving you more control over large areas.

Draw fast and spontaneously. Speed is the key to this technique so that you do not ponder over details. Rather than taking the line for a walk, it is more of a sprint! Draw over the whole page and do not concentrate on any one area, so that the whole picture gradually emerges before your eyes. In this way you get a feel for the overall drawing and can balance the dark and light areas, adjusting as you progress.

It is important that you are constantly looking at the subject, as you need to analyse the pose, light, shading and tone as you draw. Your drawing tool should rarely leave the page as it glides over the paper surface. The advantage of working in this way is that you are able to be in control while your drawing still retains a looseness. You are not reliant on the single line to create form, and by using a varying concentration of scribbles, you can create the illusion of tone and form.

For variation, try out the different media. Ballpoint pen lends itself to this way of working. Graphite block is good for both small and large formats and you are able to use an eraser, not to eradicate, but as an additional drawing tool to create tone and movement.

A one-hour pose in ballpoint pen.

AN EXERCISE IN SCRIBBLE DRAWING

For this demonstration I used ballpoint pen on A4 cartridge paper.

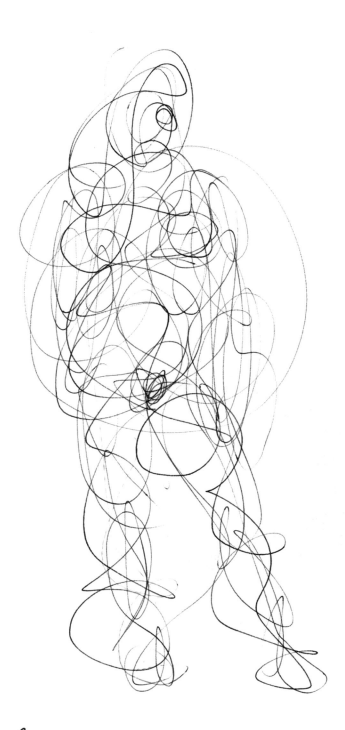

1 Faced with the daunting prospect of a blank sheet of paper, rather like a painter who kills the white surface with a colour wash, we apply the same approach with random scribbles, loosely echoing the pose. With wax crayon or ballpoint pen, you are unable to erase, but the beauty of this method is that there is no need to remove lines.

2 Scribble out the overall shape of the pose, approximating the features and reworking the whole drawing, without paying too much attention to the finished result. Notice the variation in the weight of the line. By using a light touch, you are able to produce a range of soft and hard lines, even with a ballpoint pen.

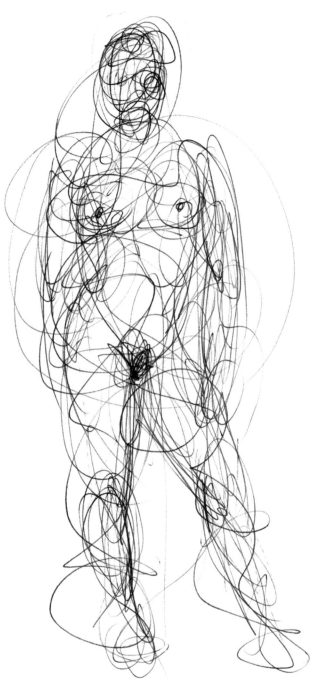

3 Once you are happy with the proportions, start to focus on the detail, reworking the line and adding weight to your marks. The image will start to grow.

4 Continue drawing over the whole image, making sure that your drawing tool hardly leaves the page and that you work fast. Start to pick out the key points and accentuate them.

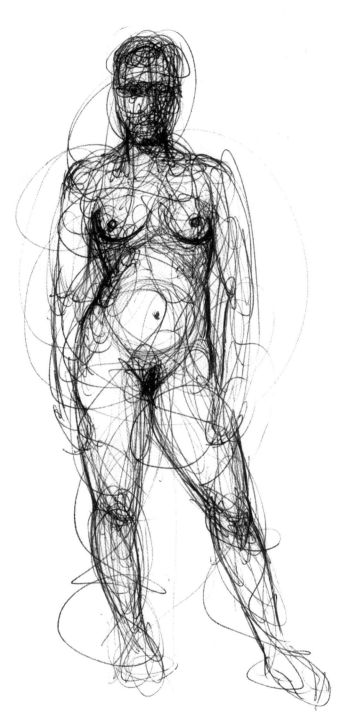

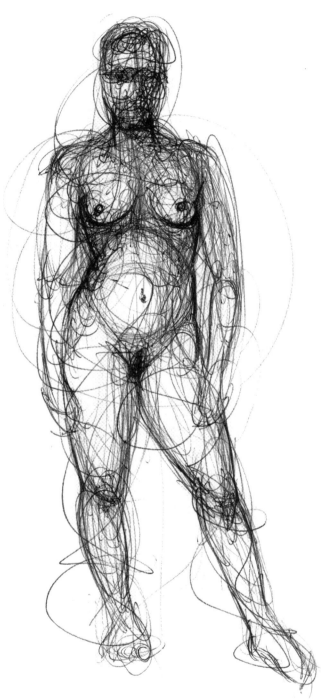

5 The hips and neck are two areas where my pen hovered and made heavier marks. By taking into account both the tone and the light hitting the body, you will give form to your drawing.

The finished scribble drawing

The skill of any artist is in knowing when to stop drawing. This picture took only twenty minutes to produce as I was working on a small A4 format.

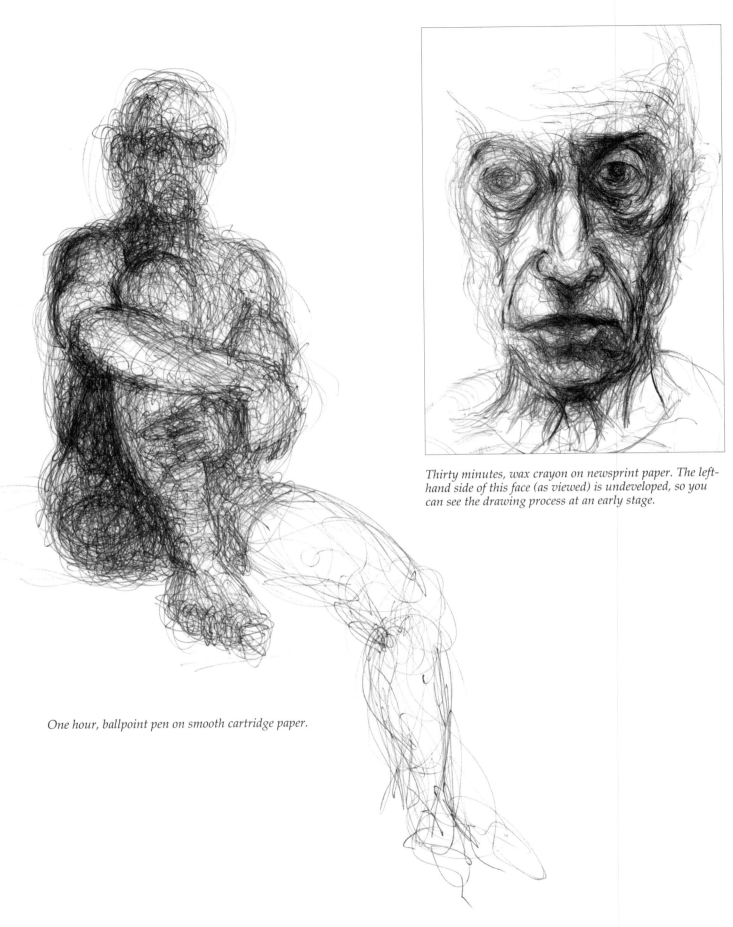

Thirty minutes, wax crayon on newsprint paper. The left-hand side of this face (as viewed) is undeveloped, so you can see the drawing process at an early stage.

One hour, ballpoint pen on smooth cartridge paper.

58

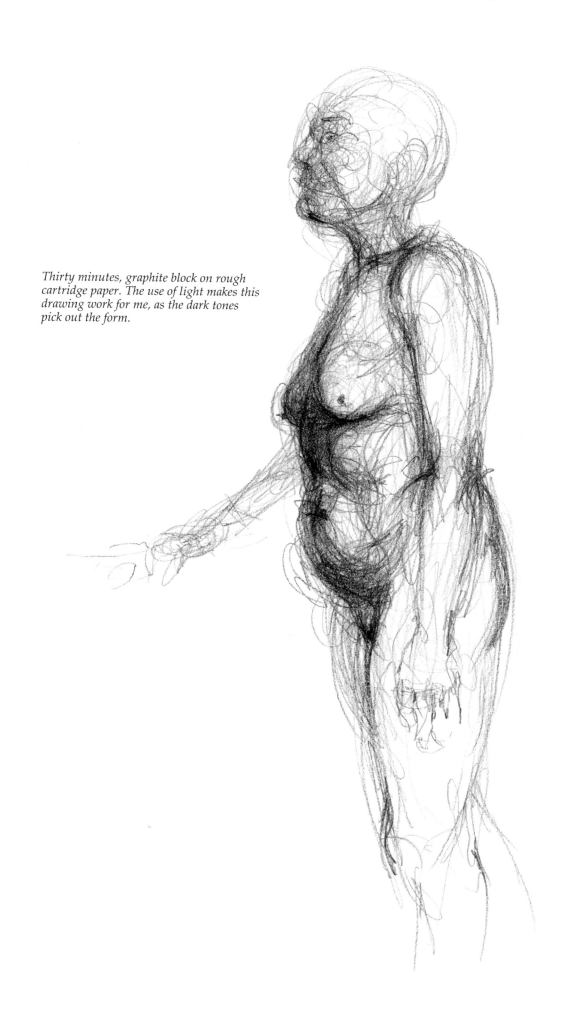

Thirty minutes, graphite block on rough cartridge paper. The use of light makes this drawing work for me, as the dark tones pick out the form.

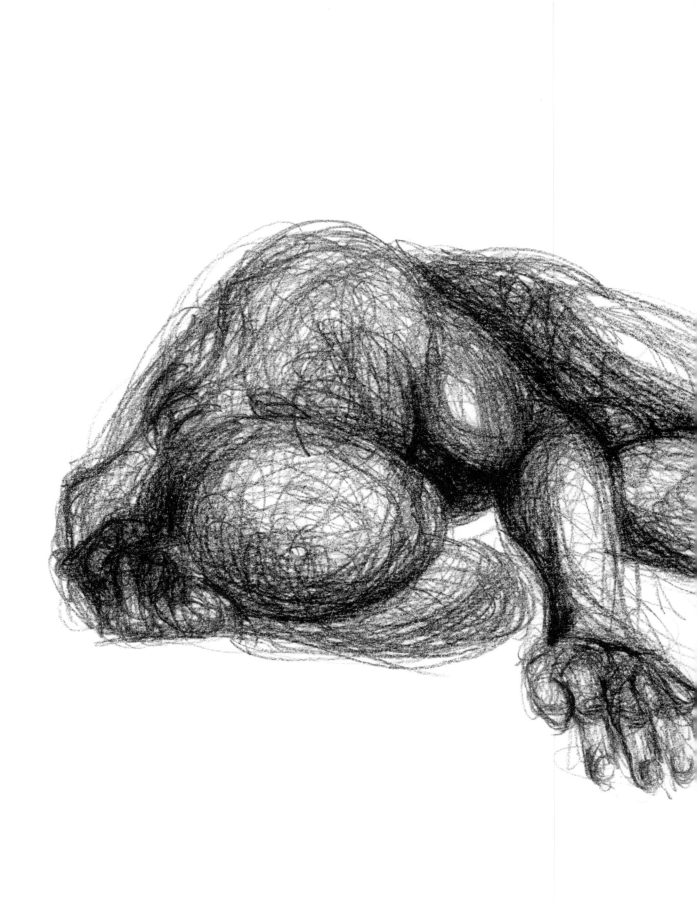

This one-hour perspective drawing, using wax crayon, lends itself to this particular way of working. The extreme foreshortening from viewing the figure at a very low angle is a difficult challenge, but because you are constantly reworking the shapes before committing, you are able to adjust as you go along and suggest the form without the use of a hard line.

Using charcoal

Charcoal is the traditional choice of medium for life drawing and, for me, the most organic. I enjoy the process of pushing the charcoal around the page with a finger or an eraser, picking out the form, adjusting and cajoling the drawing into shape.

Charcoal sticks, which are excellent for working fast and spontaneously, can cover a large area very quickly. It is an expressive medium and produces a wide tonal range from the most delicate greys to a soft black. Do not draw on too small a format with charcoal sticks as they are more suited to working on a larger scale.

Compressed charcoal on the other hand is a much harder medium and doesn't crumble. It produces a very deep black mark and is more resistant to smudging.

When producing a detailed drawing with delicate tones, work in layers, preserving key stages by using spray fixative so as not to inadvertently lift off any delicate charcoal work with the side of your hand. You can also use a piece of clean paper to rest the palm of your hand on so as not to smudge the work or deposit any grease. The natural moisture in your fingertips is excellent for lifting off surplus charcoal and I encourage you to draw with your fingers and a hard eraser.

If you overwork the drawing, you can lighten an area with white chalk, but it is preferable to allow the white of the paper to work for you. Very delicate tones and details can be tweaked with a small, stiff-bristled paintbrush. As in handwriting, we all have our own drawing style, so do not try and cultivate one, as your natural style should emerge on its own.

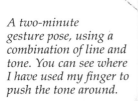

A two-minute gesture pose, using a combination of line and tone. You can see where I have used my finger to push the tone around.

A twenty-minute tonal drawing made in Tuscany.

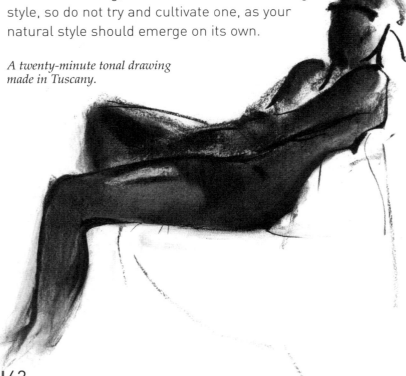

A two-minute gesture drawing in line.

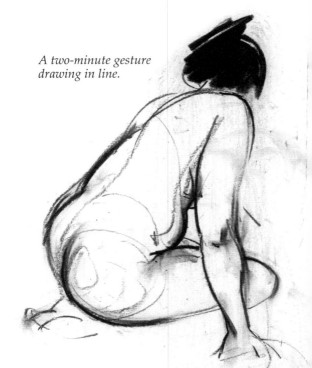

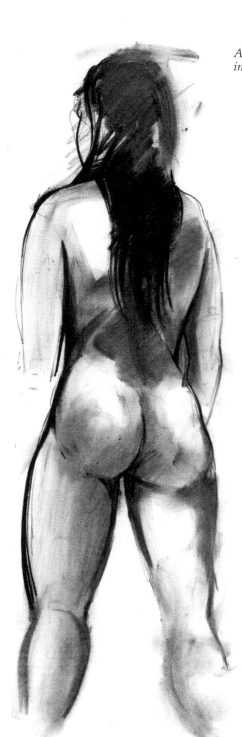

A ten-minute pose in line and tone.

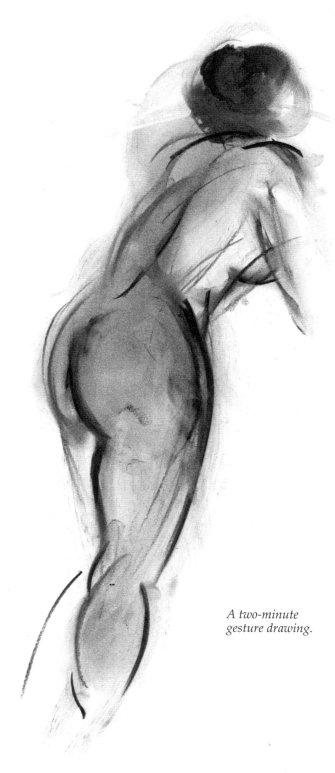

A two-minute gesture drawing.

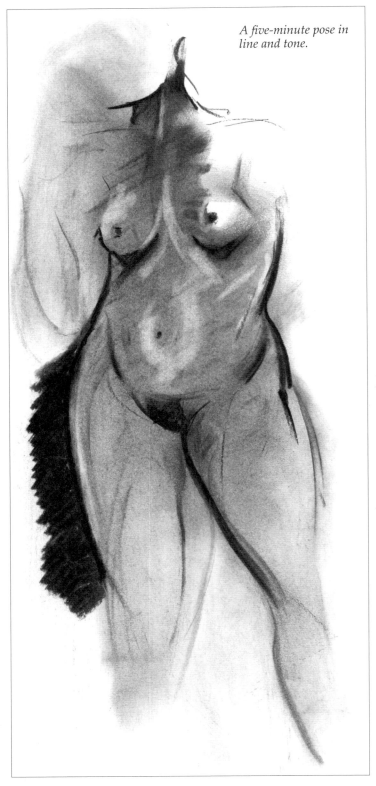

A five-minute pose in line and tone.

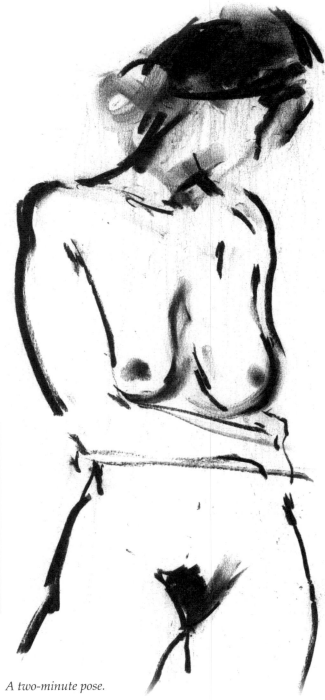

A two-minute pose.

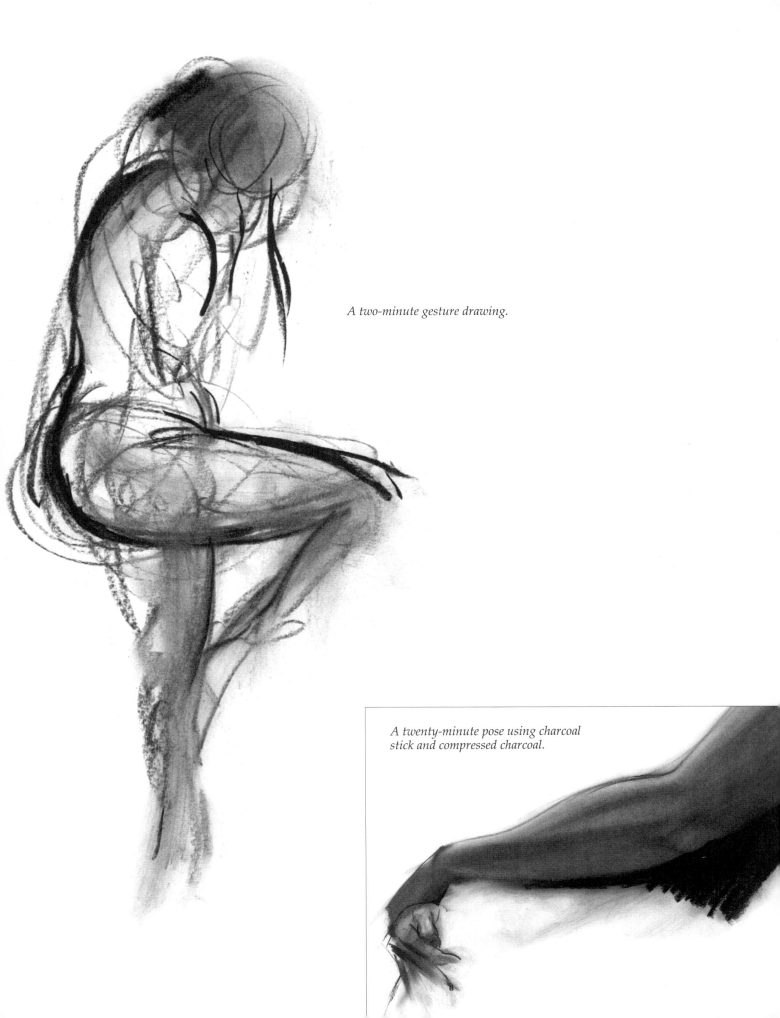

A two-minute gesture drawing.

A twenty-minute pose using charcoal stick and compressed charcoal.

AN EXERCISE IN CHARCOAL

The versatility of charcoal is demonstrated in this drawing recently produced at a workshop in Ireland. It was a comparatively long pose of thirty minutes and I was interested in catching the subtle tones produced by a soft light hitting the torso. This drawing presented an opportunity to produce a detailed study of the model, working in a more considered way and at a much slower pace than usual. To get a wider tonal range, I used a combination of charcoal sticks and compressed charcoal.

1 Quickly sketch out the drawing with a charcoal stick on cartridge paper.

2 Using your finger, lightly rework the charcoal, knocking back the hard lines to start to produce tones.

3 Continue pushing the charcoal around with your finger or use the side of your hand, which is less moist and good for spreading or lifting off the surplus charcoal. This style of drawing is achieved by working in layers, so at this point, in order not to lose the delicate tones created, apply a spray of fixative and allow to dry before continuing.

4 With the charcoal sticks, add more tone and blend with your fingers. To strengthen the very dark lines outlining the form, I used compressed charcoal in a pencil format.

5 At this point I decided that the breast further away was too dark and the nearer breast needed a highlight.

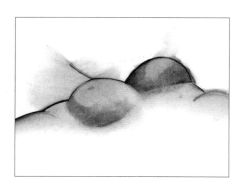

6 To lift off the surplus charcoal from the further breast, I simply placed my fingertip, which contains a lot of natural moisture, on the area and removed the unwanted charcoal. Use a hard eraser to lighten the highlighted area on the breast nearer to you.

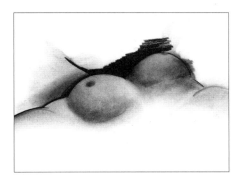

7 To start creating depth, I used compressed charcoal for the background and to outline the breasts. Apply a second spraying of fixative and allow it to dry before continuing.

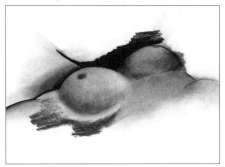

8 To assess if your drawing is looking correct, step back and view it from further away. It is much easier to judge your work from a distance. Alternatively, hold your picture up to a mirror and the reversed image will show you any faults immediately. At this stage, I added more tone using the charcoal stick.

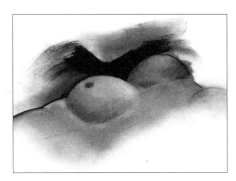

9 The smudged compressed charcoal on the neck area is a little harder to blend and control. Use a small paintbrush to work the charcoal, as fingers are too large for the job. Apply a third spraying of fixative, allowing it to dry before continuing.

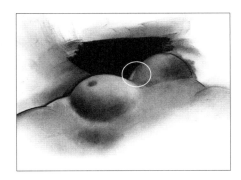

10 The mirror test showed me that the left breast was not quite the right shape, so in order to reclaim some of the deep black compressed charcoal (in the circled area), I applied some hard white chalk and reworked. Make sure that the black that you are about to work on is fixed, so that the white chalk sits on the surface, otherwise you will have an unpleasant grey smudge as the two media mix.

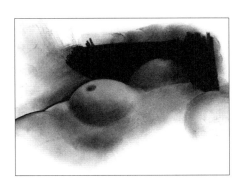

11 Using a paintbrush, dab on some crushed compressed or stick charcoal to the areas you want darker. Rework these areas with your brush. In order to do this, scribble some charcoal on the side of your paper and pick it up with the paintbrush. Blend in the charcoal to produce a subtle tone gradation.

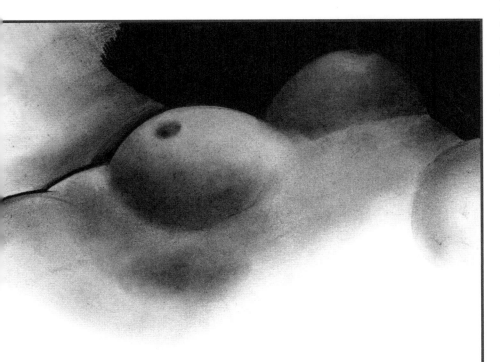

The finished drawing
When the thirty minutes are up and you have taken this study as far as you want it to go, give it one last spray of fixative.

Figure in Charcoal Stick

This is a very quick sketch, produced in about three minutes. Details such as the nose and toes have been ignored and the time has been used to capture the essence of the pose, implying form with the use of light and dark.

/ Working at an easel on a large sheet of cartridge paper in the vertical position, hold the charcoal stick between your thumb and fingertips (in the 'toothbrush' position) and work fast. Quickly outline the form, picking up on the key points and place emphasis on any strong lines and curves. It doesn't matter if a line is incorrect, just remove with some tissue or the side of your hand and redraw.

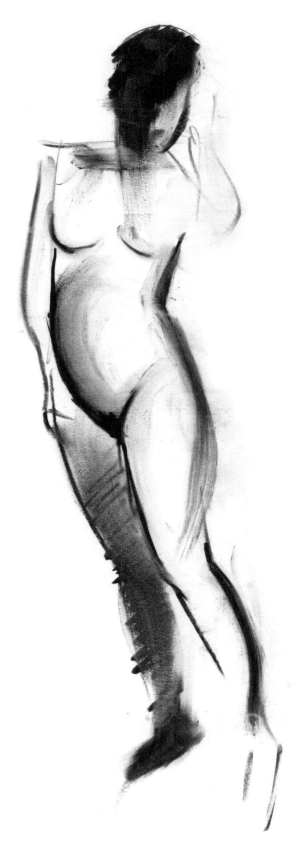

2 With your finger, work the charcoal to begin to create tone and 'push' the drawing into shape. Keep your eye on the model at all times, only glancing down to make your marks.

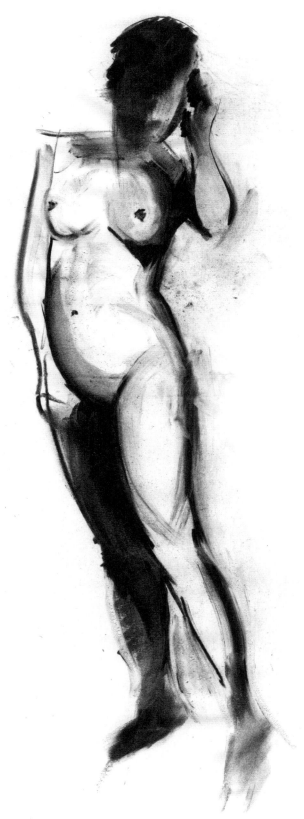

3 Adjust and strengthen the lines as you go, building up the drawing gradually. Remember this is going at a quick pace to retain spontaneity and looseness in the drawing. Do not concentrate on any one area, but work over the whole page, adding line and tone as you go. To focus attention on the front leg, I darkened the leg further away to give the impression of depth. As artists, we have the power to interpret and be creative.

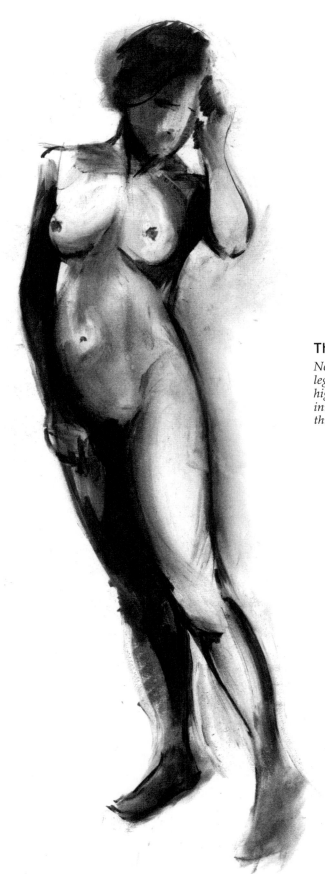

The finished drawing

Notice how in the upper part of the leg nearest to you, I have created a highlight by smudging tone on the inner thigh to give both form and depth, throwing the leg forward.

Foreshortening

The human figure is the most challenging of all 'landscapes' to interpret, because the brain has a tendency to distort our perception when drawing a foreshortened limb. The typical response of the brain is to not allow you to see angles or body mass correctly, as it tries to make sense of something so familiar yet unrecognisable through extreme foreshortening, as in the lower arm of the drawing below. To help override the tricks of the brain, I view such foreshortened situations as a series of shapes, very much as I would in a landscape.

Learn to draw exactly what you see in front of you and not what you imagine to be there, and the illusion of foreshortening will happen of its own accord if you are accurately depicting these unrecognisable forms.

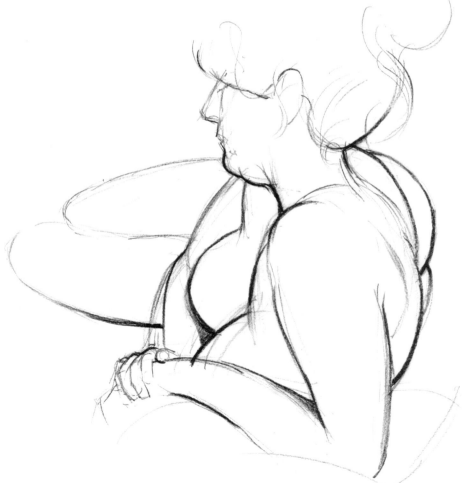

Ballpoint pen on cartridge paper. A thirty-minute pose. You can just see a faint line marking the horizon and a vertical line. This was a particularly hard pose and it was drawn quite large, so the guidelines were necessary.

Wax crayon on cartridge paper. A one-hour pose (this is a large drawing). The challenge of this pose was the model's back and lower body as they could hardly be seen.

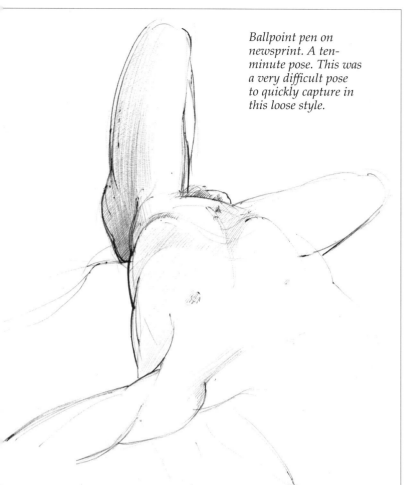

Ballpoint pen on newsprint. A ten-minute pose. This was a very difficult pose to quickly capture in this loose style.

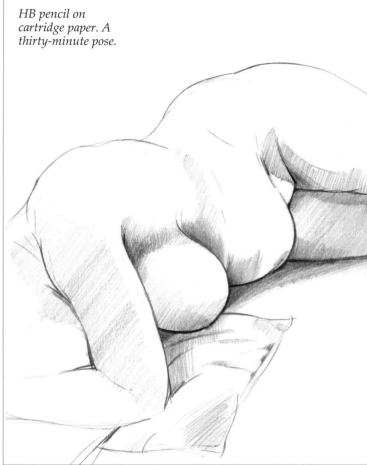

HB pencil on cartridge paper. A thirty-minute pose.

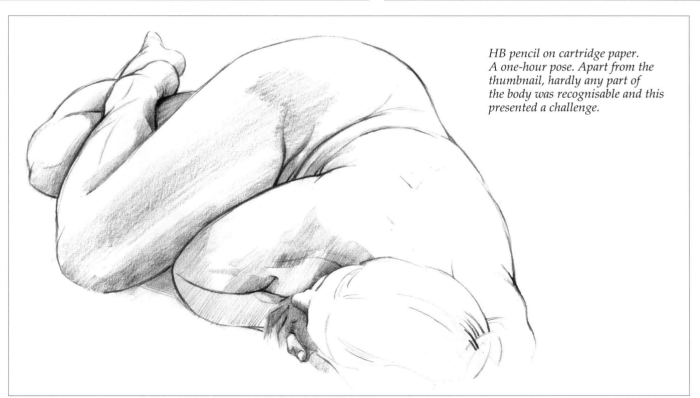

HB pencil on cartridge paper. A one-hour pose. Apart from the thumbnail, hardly any part of the body was recognisable and this presented a challenge.

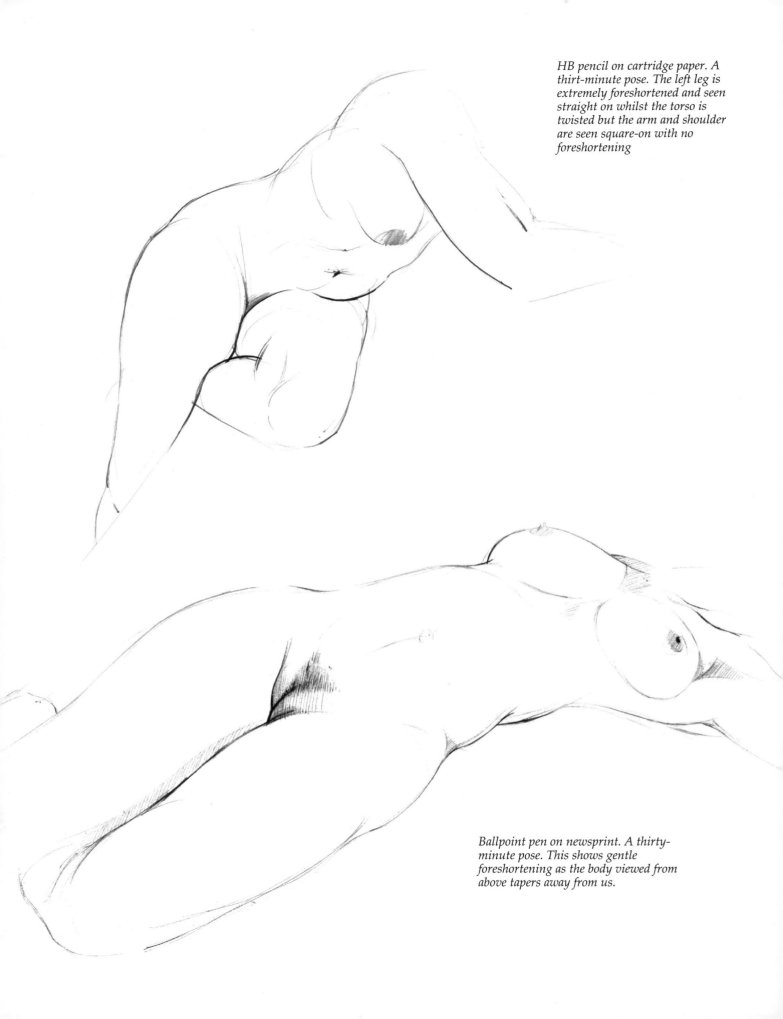

HB pencil on cartridge paper. A thirt-minute pose. The left leg is extremely foreshortened and seen straight on whilst the torso is twisted but the arm and shoulder are seen square-on with no foreshortening

Ballpoint pen on newsprint. A thirty-minute pose. This shows gentle foreshortening as the body viewed from above tapers away from us.

Ballpoint pen on cartridge paper. A thirty-minute pose. This shows a similar angle to the step-by-step drawing on pages 76–80, giving the impression of an exaggerated perspective. It is easy to miscalculate the smallness of the head or the enormity of the leg from this position and sitting so close to the model.

HB graphite pencil on cartridge paper. A twenty-minute pose. The upper body is square on, but the legs are towards us and appear large due to the foreshortening.

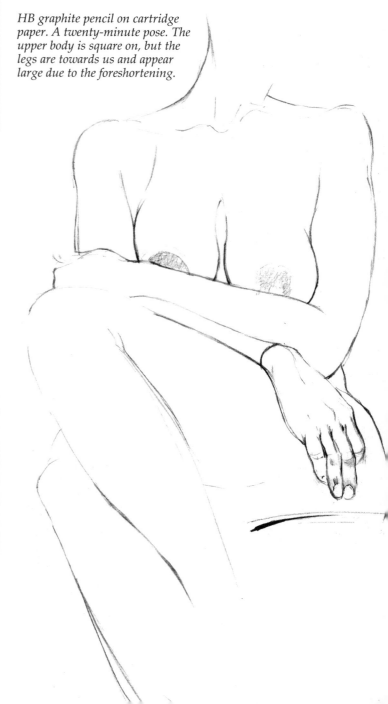

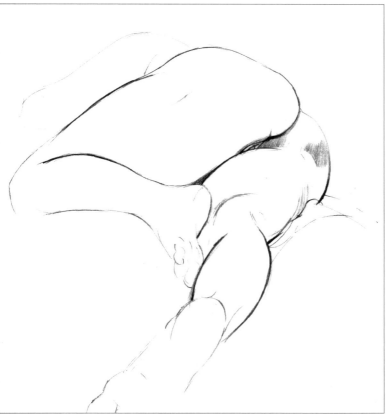

HB pencil on paper. A thirty-minute pose. Although it is not completely drawn in, you can see how large the right foot is compared to the rest of the body.

A Foreshortened Figure

Before starting this demonstration, I need to explain the position of the pose. The model is raised 75cm (30in) off the ground, lying on a table, with her feet nearest to me and her head furthest away. I am positioned at an easel, looking along the length of the body, with most of the torso obscured by the model's legs.

Before putting pencil to paper, spend a few minutes studying the pose and making a few observations. For example we see that the upper body is square on, while the legs are to one side and foreshortened. The model's right foot is the nearest thing to me. As the figure tapers away, notice how the right foot is as large as the head.

A common mistake is to draw the feet too small or the head too large, making the drawing look top-heavy and flat (see below). However, if you draw the legs and feet too large and the head too small, it can give the effect of an exaggerated foreshortening and this might produce a dynamic and interesting drawing.

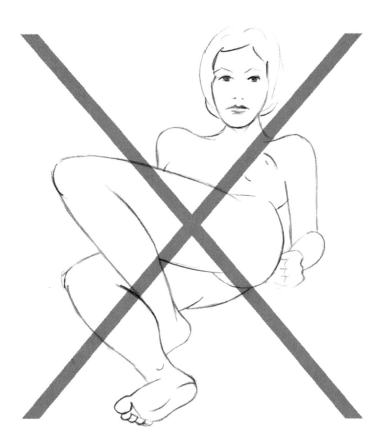

Here the feet are too small and the head is too large.

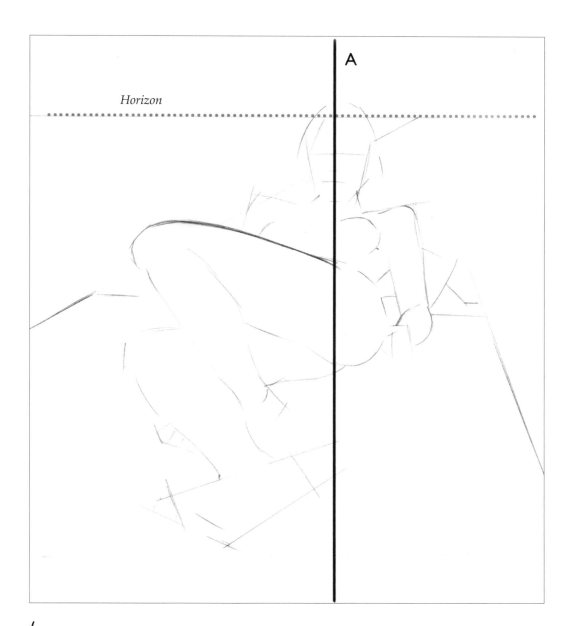

Horizon

A

I To help anchor the drawing to the page, I first draw in the horizon in relationship to the figure. The laws of perspective, although not always obvious in a life drawing, do apply and can give some guidance. Perspective is how we view objects in relationship to the horizon. In this pose, I used the table's vanishing point to help me find the horizon: the sloping lines of the table, if continued, meet on the horizon. The horizon is always at your eye level, so if I had been seated to do this drawing, the horizon would have been much lower and I would have produced a very different drawing.

To help make some sense of this foreshortened pose and to transpose it on to the page, I need other reference points. The horizon is already marked, so I next draw or imagine a line running through the body (A), in this case it is vertical and passes through the centre of the model's head, just missing the heel of the right foot. This line is invaluable: it helps me to make judgements as to where key points should be marked on the page. I can see that the right shoulder is further from the line than the left shoulder and the heel of the foot is some distance away from the line and not directly under the chin, which is on the line.

The first actual mark of the figure I make on the page in relationship to the vertical line is the upper thigh, as it is the strongest line and key to the whole pose. It is approximately the central point on my picture plane, as the torso recedes into the distance from here and the feet extend forward into the foreground. Be very aware of the depth of the drawing and see it as a three-dimensional image.

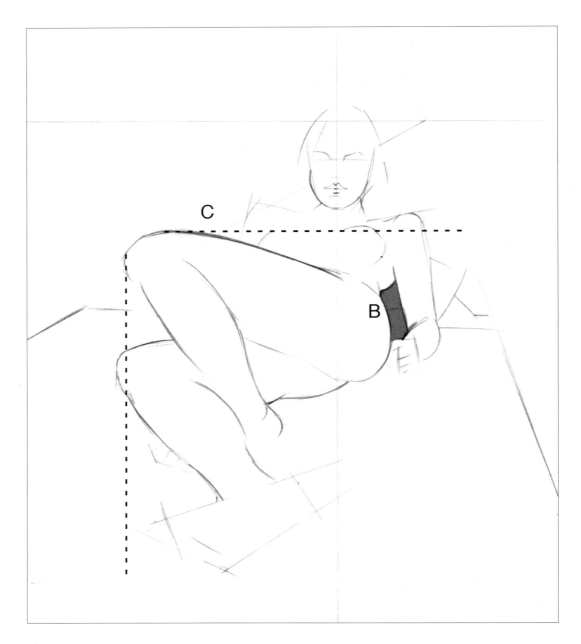

2 Observing the shapes formed around the body and between limbs (B) 'the negative spaces' are excellent reference points and of equal importance to a drawing as the figure itself. As in music, the silence between the notes are as importance as the notes themselves! Using the model's left knee as a reference point, I then 'draw' an imaginary horizontal line (C) across the page to see which points of the body this line runs through, and mark them accordingly on the page. This line also shows me that the left shoulder appears above the line and therefore higher than the knee. Likewise when I run the line vertically down the page from the same point, it helps me to place the second knee and toe of the foot. You can use many such lines when plotting a complicated foreshortened pose.

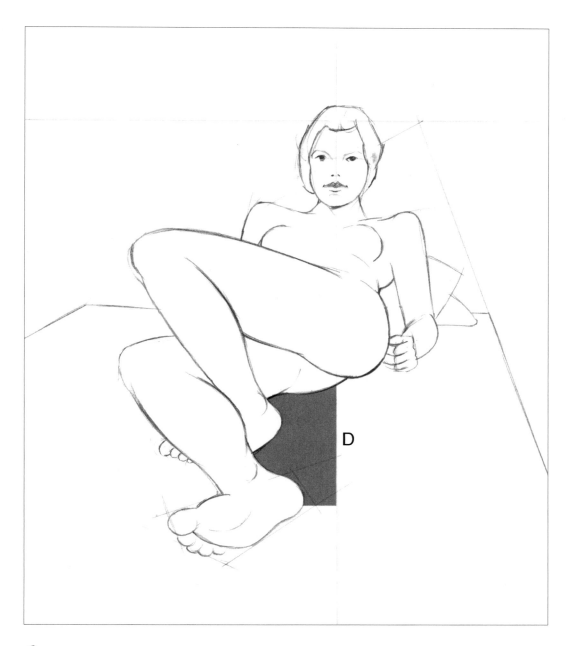

3 Using the vertical line running through the body to create a negative space (D) helps me to observe and place the contours of the lines of the leg and heels correctly.

 I continue to plot out the drawing using a combination of measuring, the negative space and a number of vertical and horizontal imaginary lines, adjusting as I go. Remember to work over the whole page, so that the drawing emerges, rather than concentrating on any one area. This way you will remain in total control and be able to adjust your marks. Once you have sketched in the whole drawing, start to strengthen your lines. Remember that life drawing is about training your eye and brain to observe and over time you will develop an eye to be able to draw without such detailed measuring and plotting.

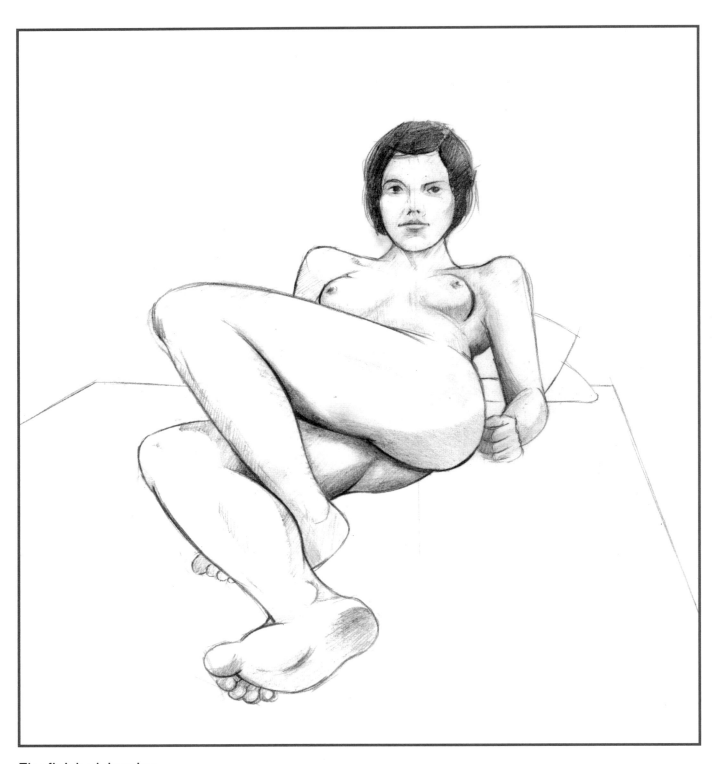

The finished drawing.

Here are two further drawings of the same pose but from different angles. Notice how the horizon has shifted in each case.

Do not be afraid of foreshortening, and select the most challanging angle to draw from. Of these three drawings of the same pose, the second was probably the most difficult and the last was the easiest as the foreshortening was minimal.

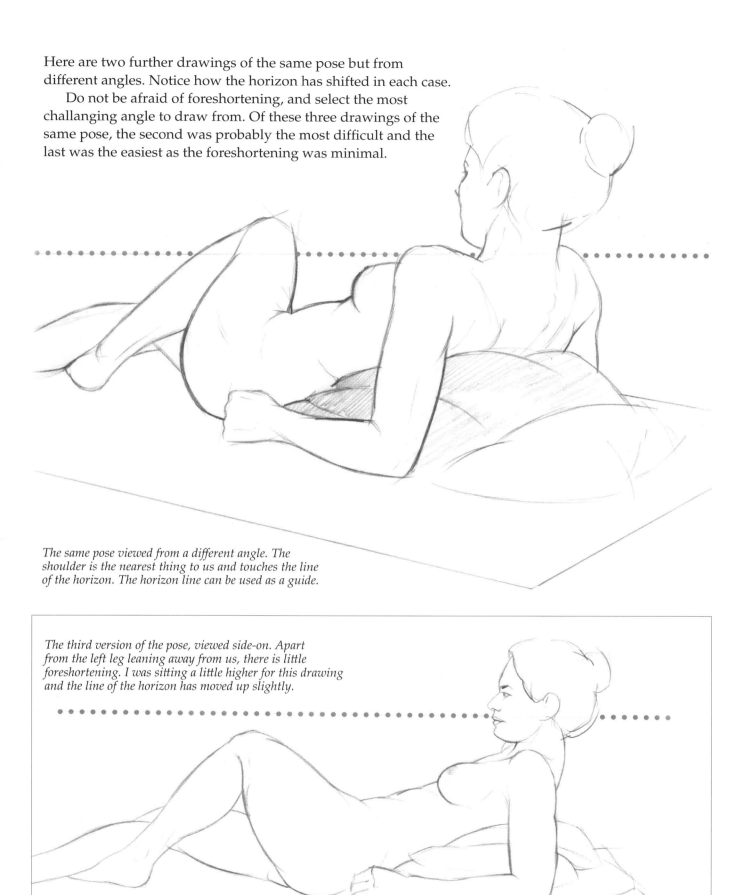

The same pose viewed from a different angle. The shoulder is the nearest thing to us and touches the line of the horizon. The horizon line can be used as a guide.

The third version of the pose, viewed side-on. Apart from the left leg leaning away from us, there is little foreshortening. I was sitting a little higher for this drawing and the line of the horizon has moved up slightly.

Faces

I have always enjoyed the challenge of drawing faces. It is an excellent discipline in understanding proportion and fine detail.

The brain is programmed to distort visual information by selecting the most prominent features and accentuating them, for example the eyes and nose. Because of this, it is easy to draw out of proportion, as these features loom large and the less significant diminish in size, such as the forehead, or the distance from eye to ear. We must learn to trust our eyes, overriding the brain, and not draw what we think we are seeing, but the reality. To help us combat this problem, I use a simple measuring system to understand the dimensions of the head as seen in profile.

Often overlooked is the problem of perceiving the volume and shape of the head accurately, but there is an easy test you can apply to pull the head into shape if you have miscalculated.

Do not worry about getting a likeness; it is more important that the eyes, ears and features are in the correct place. The portrait painter Augustus John never concerned himself about getting a likeness, nor about the criticism that followed.

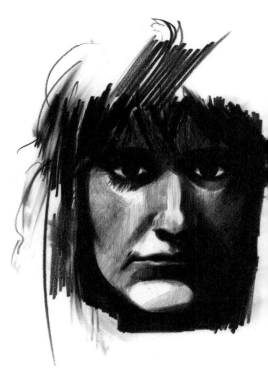

Face and head drawn in a darkened room with a lamp throwing light on to the subject. I used a range of pencils on cartridge paper: H, HB, 2B and 4B.

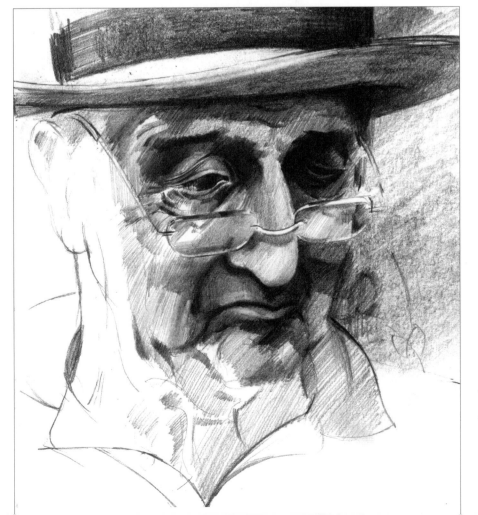

Martin Vaughan sitting reading under the sun in Tuscany. HB and 2B pencil on cartridge paper.

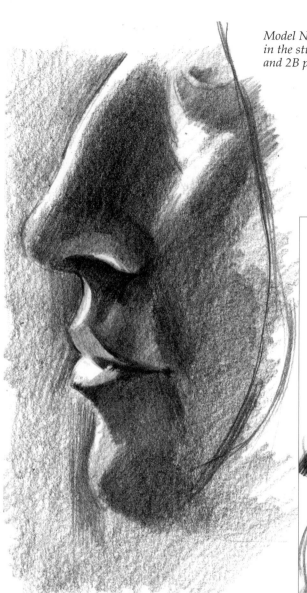

Model Nelly gently lit by natural light in the studio at La Capella, Italy. HB and 2B pencil on cartridge paper.

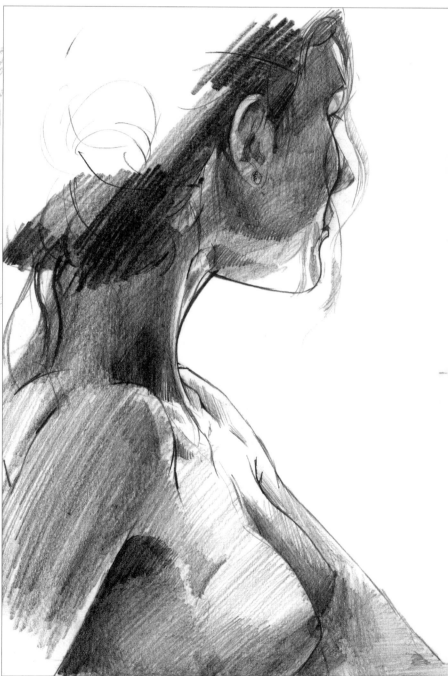

A combination of reflective light and a spot lamp illuminating Leticia's face. HB and 2B pencil on cartridge paper.

AN EXERCISE IN DRAWING A FACE

The following exercise shows my thought process and method of working when I drew this head from life during a hot Tuscan afternoon. It took about three and a half hours to complete. The drawing is quite large, approximately two-thirds life size, and was drawn with a wax crayon on a smooth cartridge paper, using an easel to avoid visual distortion (see page 28).

I used two wax crayon sticks – one blunt for general use and the other sharpened to a point for detail. Before starting, I spent some time studying the various proportions and 'drawing' the image in my mind's eye, taking into account where to place the picture on the page.

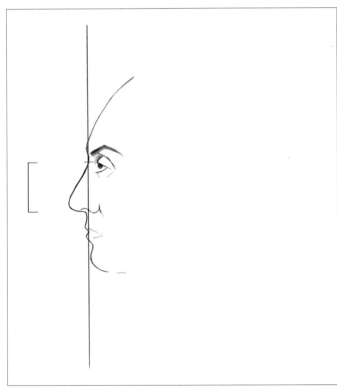

1 Lightly draw a vertical line on your paper. The line will extend both beyond the top and bottom of the head, running through the bridge of the nose. This line will now act as the basis of a grid and place the image on the page. Mark where you would like the bridge of the nose to touch the vertical line. This is my usual starting point (A). For the sake of this demonstration I have drawn all lines much more heavily than I normally would.

2 Using the vertical line as a guide and starting at the bridge of the nose, lightly draw in the profile. Observe where each feature falls in relation to the vertical line. Facial profiles vary enormously and so you cannot assume for example that all chins fall to the right of the line, as in this instance. Also, you can now use the nose length as a unit of measure to place other features and detail.

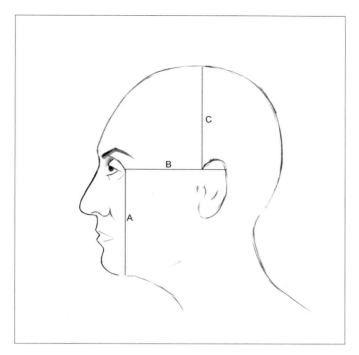

3 At this stage, ignore the hat and lightly draw in the completed head. Even though you cannot see the top of the head in the finished drawing, it will help to know where it is when you come to draw the hat outline. Looking at the head in profile, the most important unit of measurement is the distance from the chin to the corner of the eye (A). This same measurement can be used to locate the back of the ear in relationship to the corner of the eye (B) and also the top of the head (ignoring the hair) from the front of the ear (C). You can see that the eyes sit in the middle of the head.

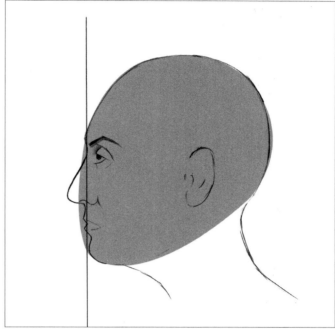

4 To check that you have drawn the volume of the head correctly, apply the 'egg test'. Yes, we are all 'egg-heads'! If you look closely at the head in profile, you will see that it is actually an upturned egg shape – the chin being the tip and the back of the head, the base of an egg. This will give you guidance to see if you have the volume and shape of the head correct. Ignore any double chins; it is the jaw bone we are looking at.

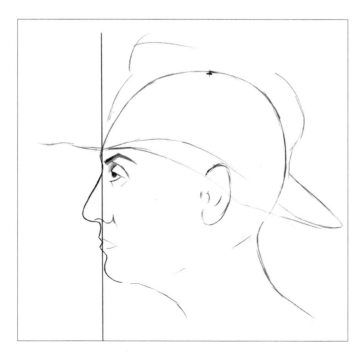

5 Once you have reached this stage, the pressure is off. Even the most experienced model will move to some degree and begin to wilt, especially if the sun is beating down on them! You can now draw in the hat at a more leisurely pace and with a degree of confidence, knowing that you have solved the head size and shape.

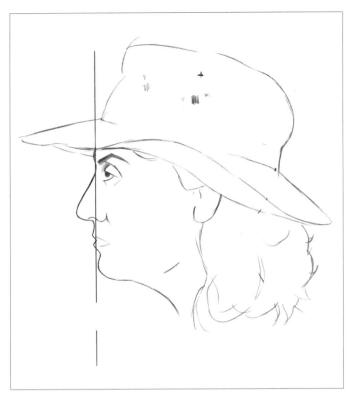

6 Quickly sketch in the remaining drawing so that you have all the elements in place before starting any detail.

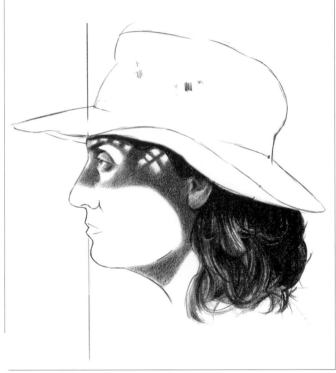

7 Because I was working in the open under a strong direct light from the sun, I quickly drew in the shadows as they hit the delicate contours of the face. The sun moves across the sky surprisingly fast and within a short time the shadow will have moved. Next, I added the hair.

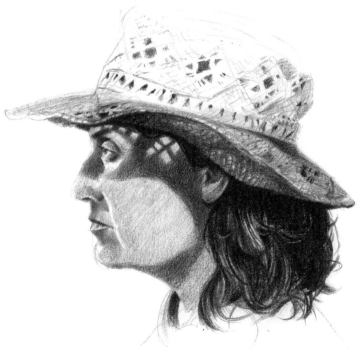

8 Finally I finished the remaining face and hat details. There are no short cuts when drawing subtleties, just careful observation, and the more your eye develops, the more you will learn to see.

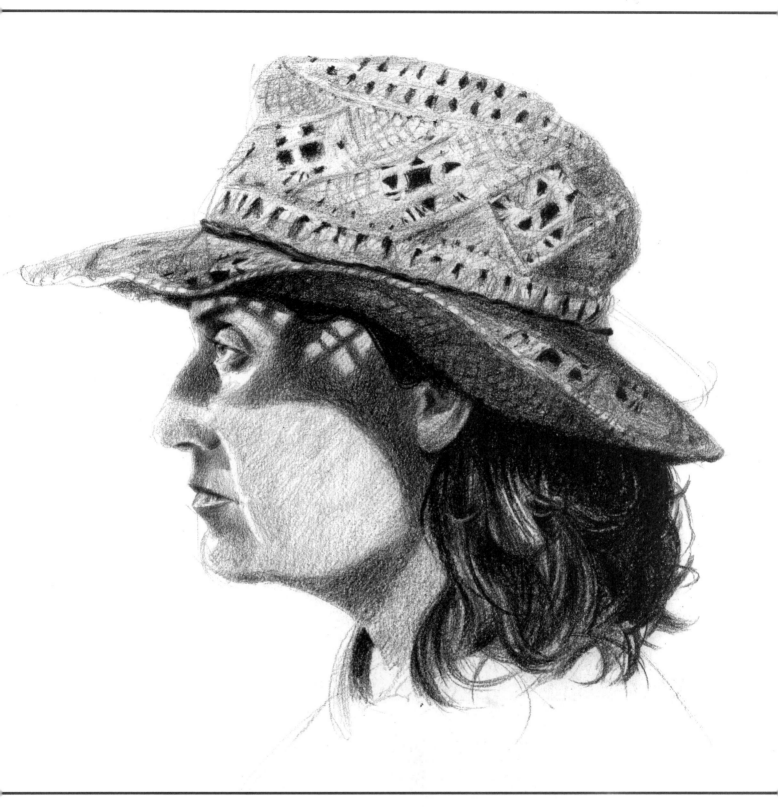

The finished drawing

Clelia drawn in Tuscany. Please draw from life, as shown here, and not from a photograph. Drawing from a flat image, you will only learn how to copy, but drawing from life you will develop your observational skills. I would prefer that you produce a less than perfect drawing from life than a beautifully copied photograph.

Hands and feet

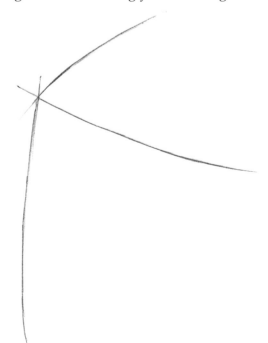

It is always a challenge to draw hands and feet, as they are unique and individual in shape, delicacy and gesture. On pages 91–95 are a selection of studies taken from my sketchbooks. They are drawn from life and although my choice of medium varies between graphite pencil, ballpoint pen and charcoal, and the styles may differ, my approach is always the same.

It is extremely difficult for a model to hold a hand pose without moving a little, so it is important to capture the basic shape quickly and build up the drawing, adding the detail as you progress. Never fall into the trap of drawing a beautifully finished, detailed finger or toe without having first sketched out the whole drawing and solved the problems of proportion and foreshortening.

The easiest and most accurate way to capture a hand gesture is to construct a simple grid or box shape so that your drawing is anchored and it is easier to solve the problem of structure.

EXERCISE IN CONSTRUCTING A HAND

I will take you through a simple step-by-step exercise in drawing a hand from life. Choose your medium; here I have used a ballpoint pen, but you may prefer to use an HB or 2B pencil on cartridge paper. Do not draw too small, as this makes it harder to get the details accurate. This drawing was made at just under life size. Make sure that the light cast is interesting and gives both shadow and highlights before starting your drawing.

1 For this particular hand pose, I started by indicating the angle of the knuckle, forefinger and upper hand with lightly drawn guidelines as a basis for our grid. Do not be too heavy-handed at this stage and use faint lines that can be easily erased or will merge in with the drawing as it builds up and develops. For the purpose of this demonstration I have drawn the lines in heavily for clarity.

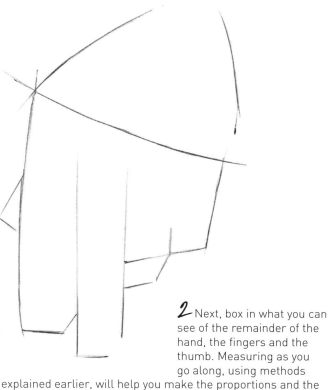

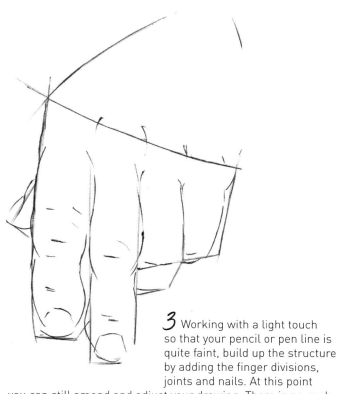

2 Next, box in what you can see of the remainder of the hand, the fingers and the thumb. Measuring as you go along, using methods explained earlier, will help you make the proportions and the distance between fingers accurate. Measuring is always a prickly issue with artists, as most do not like doing it, but it is a way of training your eye and brain. Even the most skilled eye can make a mistake, so work to a grid, either drawn or in your mind's eye.

3 Working with a light touch so that your pencil or pen line is quite faint, build up the structure by adding the finger divisions, joints and nails. At this point you can still amend and adjust your drawing. There is no such thing as a straight line when drawing the human form, so no matter how subtle the contours are, try to capture them using the box lines you drew earlier as a guide. For instance, ask yourself whether the detail you are drawing falls within the box or crosses the line?

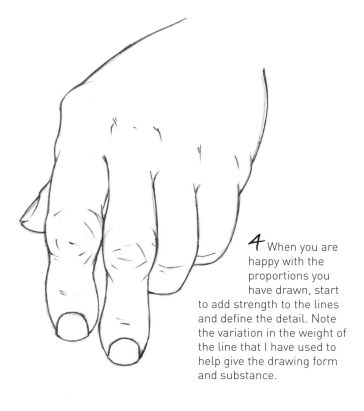

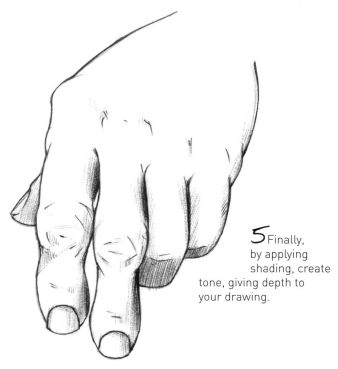

4 When you are happy with the proportions you have drawn, start to add strength to the lines and define the detail. Note the variation in the weight of the line that I have used to help give the drawing form and substance.

5 Finally, by applying shading, create tone, giving depth to your drawing.

FINGERNAILS

Fingers and toes look very strange when drawn, but once you have added the nails, this will help make the digits recognisable and determine the angle of the hand or foot, so it is important to draw these correctly. Perspective applies to fingernails as much as it does to buildings. If unsure, use the box method to help you assess the angle of the nail.

MISSING DIGITS

If a digit is partially obscured behind another, to ensure that the visible part of the finger is in the correct place and at the right angle, imagine that the obstructing finger is transparent (as artists we have the power to see through anything!) and draw the whole of the missing finger in your mind's eye, to help place the visible part of the finger and knuckle correctly.

FORESHORTENING

Hands and feet are more often than not seen foreshortened and are in reality much larger than you realise, so cross-reference by measuring. The hand may appear as large or larger than the head in extreme foreshortening – think of the famous Lord Kitchener recruiting poster from the First World War that said: 'Your Country Needs You!'

My version of the 'Your Country Needs You' poster.

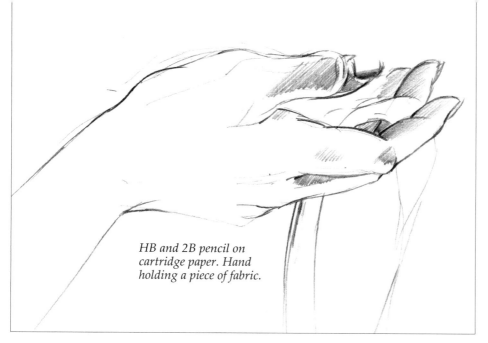

HB and 2B pencil on cartridge paper. Hand holding a piece of fabric.

2B pencil on cartridge paper. Notice the variation in the weight of the line giving a sense of depth.

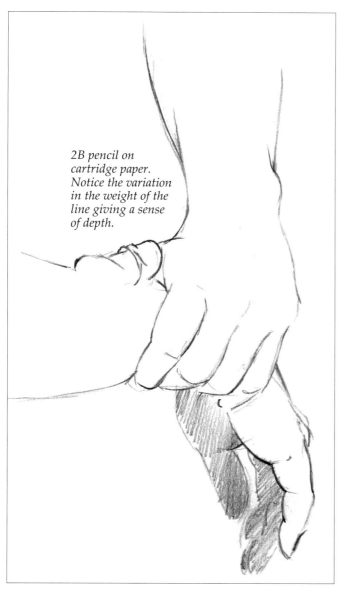

HB pencil on cartridge paper.

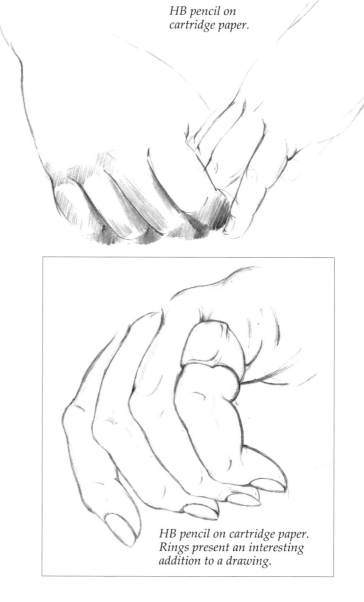

HB pencil on cartridge paper. Rings present an interesting addition to a drawing.

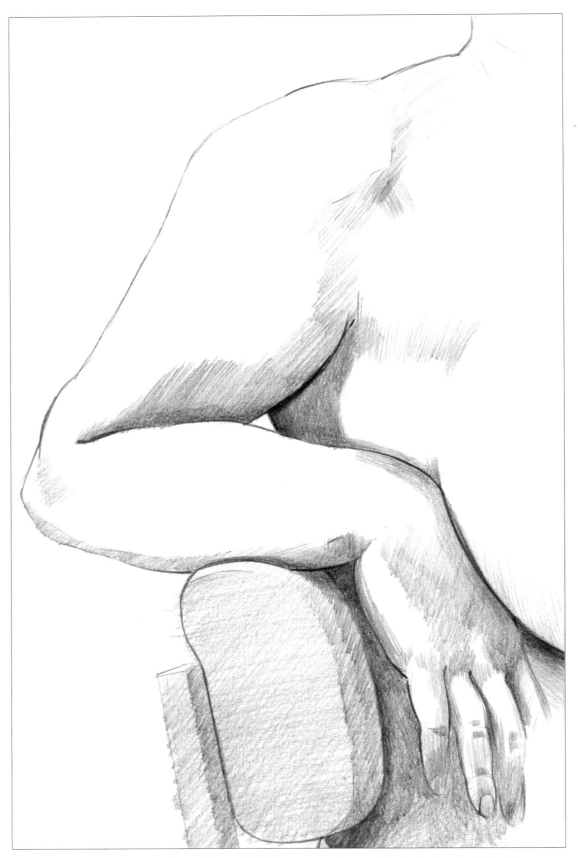

This drawing has variation in line weight and shading to create form and by including the chair, I have given some depth to the drawing.

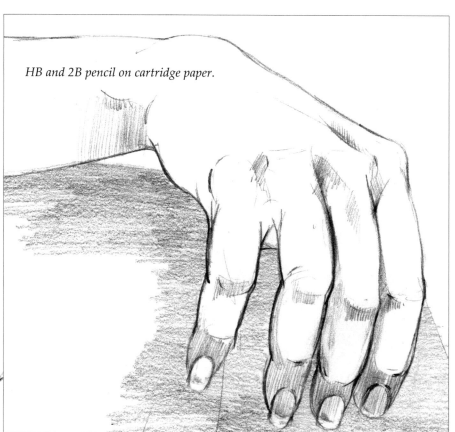

HB and 2B pencil on cartridge paper.

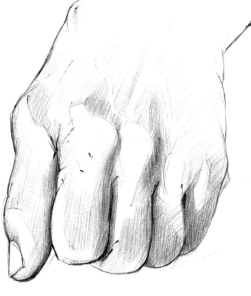

Ballpoint pen on smooth cartridge paper. With a light touch, you can get subtle lines and a variety of weights with a ballpoint pen.

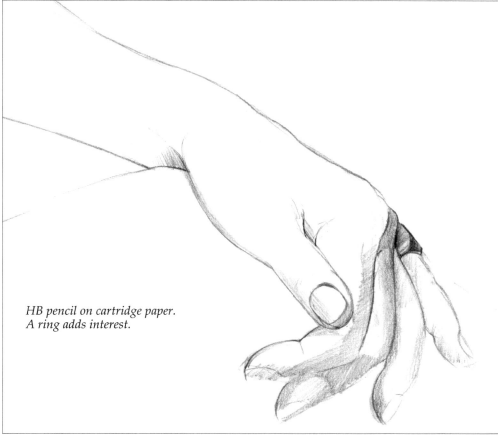

HB pencil on cartridge paper. A ring adds interest.

FEET

I use the same construction method for drawing a foot. Feet often have bunions or are gnarled and neglected, and the toes are invariably misshapen or appear squashed, but they make a challenging subject.

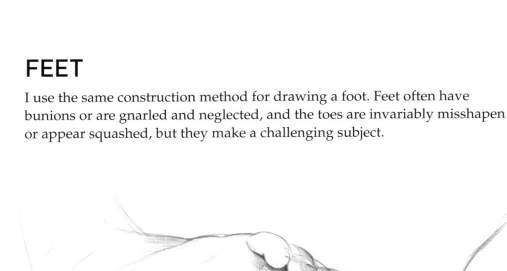

HB pencil on cartridge paper. A bunioned foot with displaced toes.

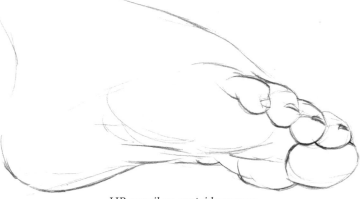

HB pencil on cartridge paper.

HB pencil on cartridge paper. Side view of a foot.

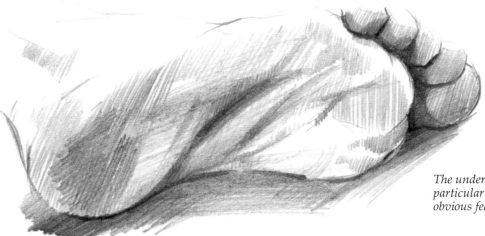

The underside of the foot is a particular challenge, as it has few obvious features.

HB pencil on cartridge paper.

A foreshortened foot in HB and 2B pencil.

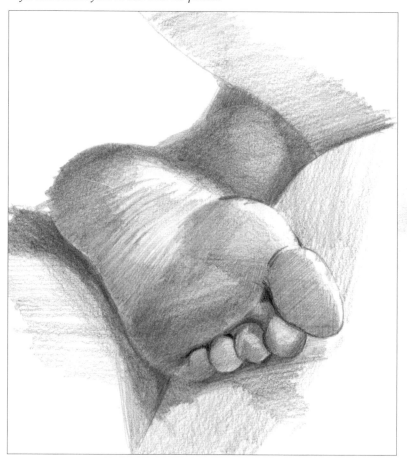

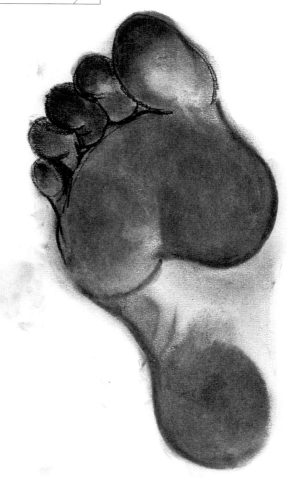

Charcoal on rough cartridge paper.

Index